# CITY OF LONDON IN 50 BUILDINGS

## LUCY McMURDO

AMBERLEY

*For Mac, with love and without whom this book could not have been written.*

First published 2023

Amberley Publishing, The Hill, Stroud
Gloucestershire GL5 4EP

www.amberley-books.com

British Library Cataloguing in Publication Data.
A catalogue record for this book is available from the British Library.

ISBN 978 1 3981 0151 7 (print)
ISBN 978 1 3981 0152 4 (ebook)

Typesetting by SJmagic DESIGN SERVICES, India.
Printed in Great Britain.

# Contents

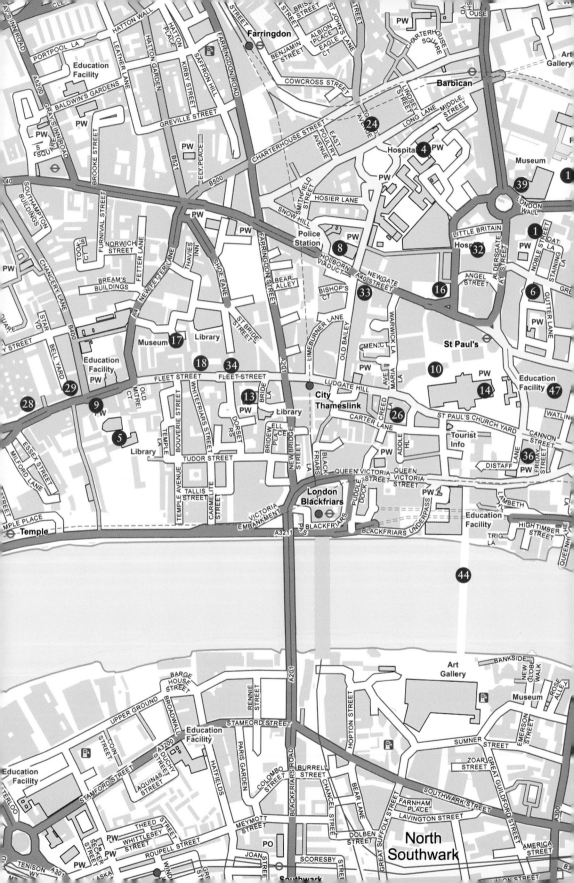

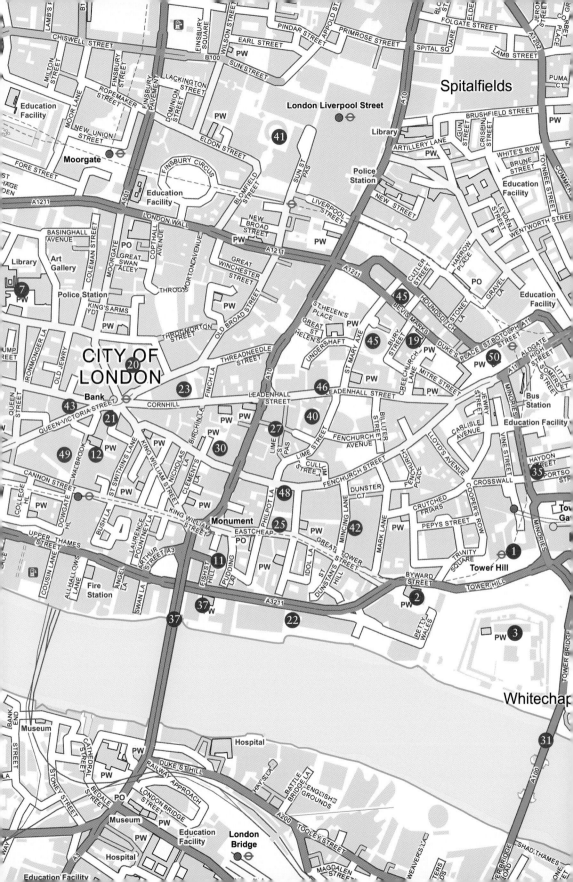

# Key

# Introduction

The City of London, commonly referred to as the City, is like no other place I know – marvellously compact and just bursting with every style of architecture you might imagine. With a history going back over 2,000 years, it is not surprising that walking along its streets and lanes you can stumble across a medieval church, remains of the Roman wall, a grand entranceway to a livery hall, a Victorian marketplace or key sites like Tower Bridge and the Tower of London (the ancient, intimidating Norman fortress still in use today). The City has really been 'discovered' during the past decade, possibly due to the ease of access to information on the internet, but also, I believe, as more and more of us have a growing interest in urban architecture. Most recently the City of London Corporation has taken the decision to establish the 'City Culture Mile' and is currently upgrading the Barbican Arts Centre's facilities and funding a large proportion of the Museum of London's move into new premises in Smithfield Market, which will undoubtedly make the area even more of an attractive destination and increase visitor numbers.

The City is not only a major global financial hub but is increasingly becoming a place that people seek out for its heritage, pageantry, spectacular contemporary buildings and artworks, and its streets and alleyways are regularly full of visitors enjoying its wonderful architecture and historic atmosphere.

Since Roman times the City of London has been a major settlement, trading post, port, and administrative hub and its governing body, the City of London Corporation, was established as an institution more than 800 years ago, even before the British Parliament. The arrival of the Romans in AD 43 led to London (then known as Londinium) swelling in both size and importance so that it developed into a substantial city with its own law courts, marketplace, fort, temples, bathhouses and amphitheatre. Towards the end of the second century a defensive wall was built around the city and although much of this has since disappeared, parts of it still exist today, often located close to or beside brutalist or postmodern buildings of recent times – a great reminder of London's past. The area enclosed by the walls covered approximately one square mile, which is why the City of London is often referred to as the 'Square Mile' and is described throughout this book as such.

Following the collapse of the Roman Empire in the fifth century, residents moved out of the walled city and settled in the area around today's Aldwych. However, threatened by foreign invaders Londoners repopulated the abandoned Square Mile in the late ninth century and it has been a major seat of power ever

since. The City authorities worked alongside their Norman invaders in the eleventh
century, set up their own system of local government headed by the Lord Mayor
of London (from the late twelfth century) and established London's reputation
as a thriving and bustling port and commercial centre from the Middle Ages. At
this time work standards were maintained by the guilds (livery companies) who
oversaw their individual trades and who held responsibility for the training and
welfare of their members. In time the guilds became extremely powerful bodies
on the political, social and religious scenes and were wealthy entities owning
great estates as well as their own grand livery halls. Unfortunately, during the
Great Fire of London in 1666 a great number of the medieval halls were burned
down, necessitating the construction of new buildings, usually on the same plots.
These were equally as opulent as their predecessors and exhibited interiors with
magnificent woodcarving, furnishings, and ornamentation. Many still exist
today (despite wartime bombing and subsequent renovation) but are generally
closed to the public, unless you are lucky enough to attend a function or a special
exhibition or perhaps visit during the annual London Open House festival in
September. Although the role of livery companies has evolved over the centuries,
the companies are still greatly involved in education as well as charitable activities
and many offer bursaries and training and have strong associations with schools,
colleges and universities.

The City was totally devastated by the Great Fire that broke out in September
1666. It lasted for five days before the inferno was quelled and resulted in the
loss of 13,000 houses, forty-four livery halls and eighty-seven churches (including
St Paul's Cathedral). Many other buildings, such as the Guildhall and Royal
Exchange, were also severely damaged. Despite exciting plans to rebuild the City
with large boulevards and squares, this did not materialise. The City re-emerged
much as it had been before the fire and the medieval network of small, narrow
alleys and passages was once again established. In the aftermath of the Great Fire
many Londoners moved west, away from the City's devastation and built new
homes there. Sir Christopher Wren, as Surveyor to the King's Works, was largely
responsible for a large part of the rebuilding programme. Much of his work can
still be seen in the outstanding churches that exist all around the City, as well as in
his masterpiece, St Paul's Cathedral. Some of these buildings were again subjected
to horrific fire damage during the Second World War (1939–45). At this time it
was the areas around the River Thames, St Paul's Cathedral and the Barbican
that suffered the most terrible devastation, resulting in the flattening of many
warehouses, industrial premises, offices and dwellings. The loss of homes meant
that many residents, as in the aftermath of the Great Fire, chose to move away
from the City, this time into London's suburbs, depleting the City of its residents.
In order to address this exodus, the City of London Corporation commissioned
the rebuilding of the Barbican district to bring people back into the Square Mile
so that it would once again be a place where people both lived and worked. The
project, which resulted in the iconic, if perhaps somewhat menacing-looking,

brutalist-style estate, took almost twenty years to complete and has long been the source of much discussion and debate on account of its design. Whether you like it or not its construction led to the repopulation of the City and it is still considered to be a most fashionable place to live.

In the latter part of the twentieth century the City's skyline altered dramatically as enormous office blocks such as the NatWest building (since renamed Tower 42) appeared. At 183 metres (600 feet) tall, it was the highest building in the City until 2011 since when it has been surpassed by ever taller and more dynamic structures. Most of these high-rise buildings are located in the eastern sector of the City in a cluster that seems to grow all the time. Currently there are many buildings awaiting planning permission and certain buildings, such as the Gherkin and the Walkie Talkie, have become real landmarks. They are not only unusual and attractive structures but also have the added advantage of offering public viewing galleries or dining facilities on their top floors, giving visitors magnificent panoramic views of London.

There are more than 600 buildings in the Square Mile that appear on Historic England's register of listed buildings. These cover a range of buildings that represent architectural styles from Roman through to the Georgian and Victorian periods, and even buildings from the recent past such as Lloyd's of London headquarters and No. 1 Poultry. Through listing the buildings gain protection from alteration and are subject to strict planning regulations requiring listing consent from Historic England before alterations can be put into effect. Many of the buildings found in the following pages are listed – designated as Grade I, II* or II, and their rankings (from Grade I at the top) denote the national architectural and historic significance of each building.

The City is the home of legal London and also contains a World Heritage Site, the Tower of London (although strictly speaking the Royal Courts of Justice on the Strand, Tower Bridge and the Tower of London sit just outside the present City's boundaries). It is the UK's chief financial centre, and where many major national and cultural institutions as well as the highly successful commercial Broadgate Estate are based. The City is furthermore celebrated for its seventeenth-century Wren churches as well as its stunning modern architecture. The latter showcase the work of many internationally renowned architects and architectural practices including Chamberlin, Powell & Bon, Foster + Partners, Rogers Stirk Harbour & Partners, James Stirling, Rafael Vinoly, SOM, Foggo Associates and Kohn Pederson Fox. In many respects the past fifty years demonstrate the output of two men in particular, namely Sir Richard Rogers and Sir Norman Foster. They, just like Sir Christopher Wren in the 1600s, have made an enormous impact on the appearance of the Square Mile, giving it new life and providing all who visit impressive and extraordinary buildings to enjoy.

My aim in writing this book has been to provide a snapshot of architectural styles that represent the City's wonderful evolutionary history. As you can imagine writing about just fifty buildings in an area of such a rich stock of them has been

an enormously challenging task. Sadly, for each building included many others, probably equally as worthy, have had to be left out. However, it is my hope that the book is a fair representation of the City's splendid buildings and highlights why it is such a fascinating place to visit.

How to Use This Book

In accordance with the 50 Buildings series, the buildings appear in chronological order according to the time of their original construction.

Please note that the City of London is frequently referred to as the 'City' or the 'Square Mile' throughout the book and that the map identifies each building by a number that corresponds to the numbers used in the text.

Website information for buildings that are open to the public is provided at the end of each chapter.

# The 50 Buildings

## 1. Roman Wall, Tower Hill, Noble Street and the Barbican

Up until the first century AD London would have been little more than a settlement beside the River Thames and hardly the major trading centre it became following the Roman invasion in AD 43. The arrival of the Romans led to London becoming the northern outpost of the extensive Roman Empire and was where, over the course of four centuries, a range of public institutions were established.

Throughout the years following their fifth-century departure Roman artefacts were discovered in and around the City of London, but more recently major archaeological excavations have exposed the remains of a Roman basilica (city hall), forum (marketplace), law courts, temples, public baths and a vast amphitheatre, all enclosed within the City walls.

Although little remains of the original second-century Roman wall the parts that have survived are highly impressive and give us an idea of its solidity and what a

Roman wall, Cooper's Row. (© A. McMurdo)

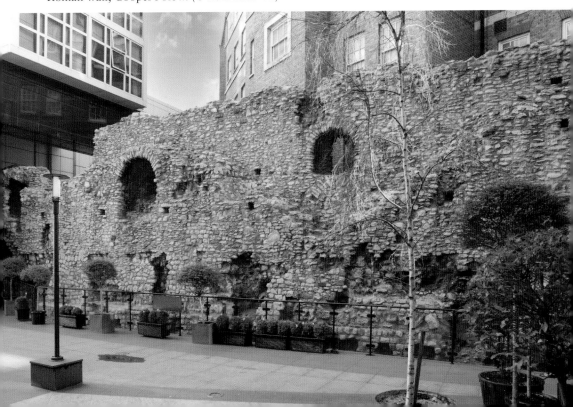

Roman wall, Tower Hill. (© A. McMurdo)

mighty stronghold it must have seemed to both the people visiting the town and its own residents. The wall encircled the city that was bordered by the River Thames in the south. It was approximately 2 miles (3.2 kilometres) long, extending between Blackfriars, the Barbican and the Tower of London and incorporated a fort in the north-western part of the city. Its construction would have been an enormous undertaking, employing an army of workmen as well as skilled artisans to shape the hundreds of thousands of squared Kentish ragstone blocks needed for the structure. In order to ensure the wall's stability and strength layers of flat red tiles were placed at regular intervals along its height. Good examples of this can be seen at both the section of wall beside Tower Hill Underground station and at the wall located to the north of the station in Cooper's Row. The wall's final construction including its battlements would have stood around 6.3 metres (20 feet) tall, had walls around 2.5 metres (8 foot) thick as well as an exterior ditch for defensive purposes.

The route of the Roman wall around the City can be found online at www.colat.org.uk and excellent detailed information about its sections is displayed in a series of panels along its course.

*Stations: Tower Hill, Tower Gateway, St Paul's, Barbican*

## 2. All Hallows by the Tower, EC3

This fine church lies immediately beside the Tower of London and has been a place of worship for more than 1,300 years. Today All Hallows by the Tower forms a major landmark with its striking baroque, copper-clad spire and is clearly visible

from a distance. The church spire was added in the 1950s when All Hallows was rebuilt following its wartime devastation. Severe bomb damage left little standing apart from its fifteenth-century walls and seventeenth-century west tower, yet in the ruins Saxon and Norman remains of earlier buildings were revealed and these are now proudly on display within the crypt and inside the church.

The crypt is well worth a visit for its many historic and archaeological treasures as well as its church registers, which contain the records of two famous Americans. The first, William Penn (1644–1718), was born in nearby Seething Lane and subsequently baptised at All Hallows. At the age of thirty-seven, Penn was granted a land charter in North America by Charles II and became the first governor and proprietor of the new American colony named Pennsylvania. Penn was not only responsible for writing the colony's constitution but also for allocating land to settlers. Pennsylvania was run as a Quaker settlement and before long people seeking religious tolerance as well as Quakers from all over Europe moved here to

All Hallows by the Tower. (© A. McMurdo)

Saxon arch in All Hallows by the Tower. (© A. McMurdo)

start new lives. Although William governed Pennsylvania for many years his final years were spent in England.

John Quincy Adams (1767–1848), the second American associated with All Hallows, was married in the church in 1797 and later served as the sixth President of the United States of America from 1825 to 1829.

Fortunately, All Hallows was left entirely unscathed during the Great Fire of London 1666. Admiral Penn (William Penn's father) and the famous diarist Samuel Pepys were quick to build a firebreak preventing the spread of the fire and this certainly saved the church from destruction. Pepys, in his diary, describes how he rushed to inform the king of the calamity after surveying the fire from the church tower.

*Station: Tower Hill*                                        *www.ahbtt.org.uk*

## 3. The Tower of London, EC3

The Tower of London, a UNESCO World Heritage Site, sits on the edge of the City of London's boundary beside the River Thames and is undoubtedly one of London's most recognised buildings. The Tower, officially known as 'Her Majesty's Royal Palace and Fortress, the Tower of London', was constructed after the accession of William of Normandy to the English throne in the late eleventh century. With walls 30 metres (98 feet) tall and 5 metres (16 feet) thick it was built to impress and intimidate invaders and Londoners alike. Successive monarchs

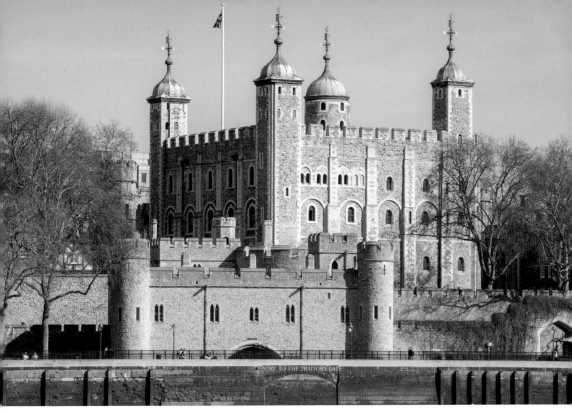

*Above*: The Tower of London. (© A. McMurdo)

*Below*: *Blood Swept Lands and Seas of Red* art installation, commemorating the outbreak of the First World War at the Tower of London, 2014. (© A. McMurdo)

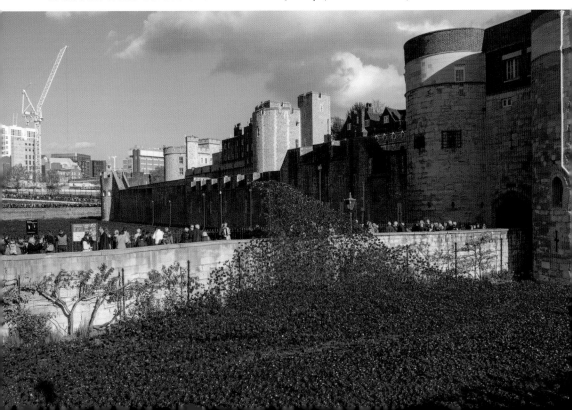

introduced new defences, towers, and a moat around the fortress so that today the Norman keep, the 'White Tower', is encircled by two defensive walls, making it appear all the more formidable.

Historically the Tower housed the nation's Armoury, Treasury, Mint, Public Records, zoo, observatory, prison, the Royal Wardrobe and the Crown Jewels. The latter have always drawn in the crowds and are still one of the Tower's main attractions. They are a stunning and priceless collection of gemstones and royal regalia used in coronation ceremonies. The internationally renowned Cullinan I and II and Koh-i-Noor diamonds set within the Imperial State Crown, the Sovereign's Sceptre with Cross and the Crown of Queen Elizabeth the Queen Mother are beautifully displayed within a vaulted room.

Despite its early use as a palace the Tower is first and foremost a castle, with over twenty towers. Current residents include the Constable of the Tower, a doctor, chaplain, and a complement of thirty-three beefeaters (the Yeoman Guard), but no royal personages have lived here since the 1500s. The beefeaters, ex-servicemen and women, are easily recognised by their splendid dark blue or ceremonial bright red Tudor uniforms. It is they who delight tourists with anecdotes about prison escapes, torture and the executions of three queens of England. The beefeaters also act as custodians of the Crown Jewels and participate in activities such as the nightly Ceremony of the Keys. One of their number, the Ravenmaster, is responsible for the safety and well-being of the Tower's resident ravens, without whom, legend states, the Tower would crumble and the kingdom would fall.

*Stations: Tower Hill, Tower Gateway*                    *www.hrp.org.uk*

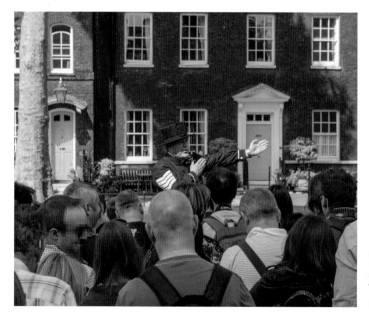

Beefeater leading a tour at the Tower of London. (© A. McMurdo)

Battlements at the Tower of London. (© A. McMurdo)

## 4. St Bartholomew the Great, West Smithfield, EC1

St Bartholomew the Great is a Grade I listed medieval church renowned for its stunning Norman architecture characterised by heavy columns, piers and round arches and is certainly one of the City of London's most impressive churches. With such a magnificent and atmospheric interior, it is no surprise that so many film-makers have been drawn to use the church as a film location. Many will recognise its setting as the church of the fourth wedding in *Four Weddings and a Funeral* (1994), and in scenes in the movies *Shakespeare in Love* (1998), Guy Ritchie's *Sherlock Holmes* (2009), *Transformers: The Last Knight* (2017) as well as a host of other excellent period dramas and television programmes.

St Bartholomew the Great was founded in the early twelfth century by Rahere, who had been a jester in the court of Henry I. While on a pilgrimage to Rome he became very sick and vowed to establish a hospital and priory in London should he survive his illness. On making a full recovery he fulfilled his pledge and began construction in Smithfield in 1123. The Augustinian priory extended over a large area and thrived for over 400 years where it had a reputation for healing the sick. The original church was much larger than St Bartholomew's today, but under the Dissolution of the Monasteries legislation the priory was closed down and many of its buildings were dismantled. Later in the century it became a parish church, but only the crossing, choir and one bay of the nave of the early Norman church were saved. Other parts of the building were put to secular use as a school, stables,

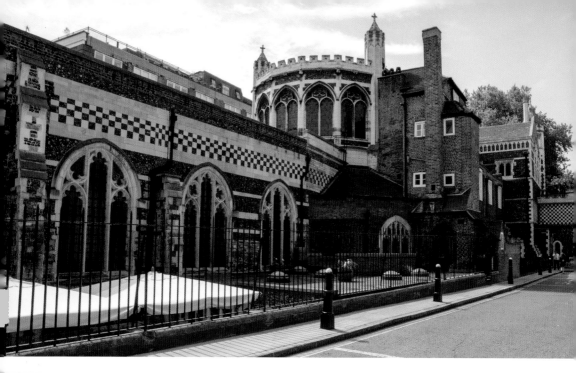

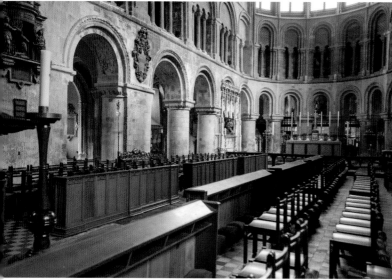

*Above and left*:
St Bartholomew
the Great Church.
(© A. McMurdo)

a forge and even a printing shop. The latter was where the diplomat, scientist, and author Benjamin Franklin worked as a journeyman printer in the early 1720s.

Step inside the church to see the founder Rahere's grand and colourful tomb and the fifteenth-century font where the painter and social critic William Hogarth was baptised in 1697. Outside one can sit in the raised garden, a former graveyard, and enjoy the beauty of St Bartholomew's wonderful flint and stone exterior.

*Station: Farringdon*                    *www.greatstbarts.com*

5. Temple Church and the Inns of Court, EC4

Unlike the majority of City churches, Temple Church is a royal peculiar that is headed by a master and is subject to the direct jurisdiction of the monarch. Unique within the City for its round shape, it is modelled on the Church of the Holy Sepulchre in Jerusalem. The church was built in the late twelfth century by a group of soldier monks, the Knights Templar, and was their headquarters in England. In 1240, a glorious chancel, a truly outstanding example of Early English Gothic architecture, was built to house the future grave of Henry III (who was later buried not at the church but in Westminster Abbey). It is here that one finds the tomb effigies of many Knights Templar as well as that of one of Magna Carta's greatest protagonists, William Marshal. Temple Church may appear familiar if you have seen the movie *The Da Vinci Code* (2006) as the chancel was the setting for one of the clues the heroes had to solve. Today the church is particularly renowned for its weekly organ recitals.

   In time the land passed to the Knights Hospitaller, an order of nursing knights. In the 1300s they leased the estate to two societies of lawyers, namely Middle and Inner Temple. The lawyers of these Inns of Court have occupied the site ever since and established campuses like those of the Oxford and Cambridge colleges;

Temple Church. (© Temple Church)

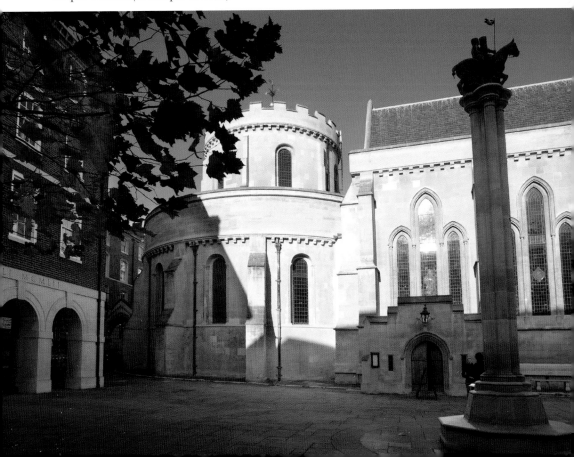

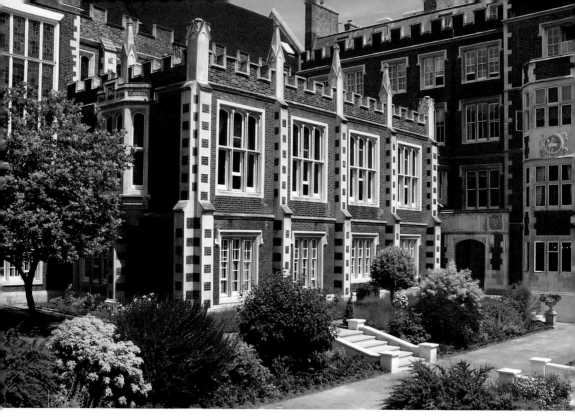

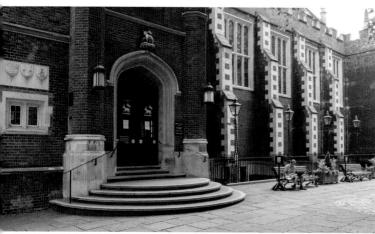

*Above*: Middle Temple Inn. (© The Honourable Society of the Middle Temple)

*Left*: Middle Temple Hall. (© A. McMurdo)

each has a dining hall, library, chapel, quadrangles, gardens as well as chambers (now offices, formerly accommodation). The buildings and exterior furnishings (including railings, drainpipes, façades) of each are easily recognised – Middle Temple by the emblem of a lamb and staff, while Inner Temple features Pegasus, the flying horse. The hall at Inner Temple is a modern post-war restoration, yet Middle Temple retains its striking red-brick Elizabethan exterior. It is particularly famous for its carved hammerbeam roof under which Shakespeare's *Twelfth Night* was premiered in 1602.

The gaslights, cobbled streets and manicured gardens that surround the Temple buildings have meant that both Inns of Court have provided the backdrop to many movies, including *The Wolfman* (2010) and *The Good Shepherd* (2006).

*Stations: Temple, Blackfriars*                    *www.templechurch.com*

## 6. The Goldsmiths' Company, Foster Lane, EC2

The Worshipful Company of Goldsmiths has occupied this site since around 1366 and the current building, the third one to be built here, was designed in 1829–35 by the architect Philip Hardwick (1822–92). Constructed in Portland stone, it is a detached three-storey building with a main façade that is easily identified by many classical features, such as its attractive cornice, a central portico of Corinthian columns, window balconies, and pediments above the first-floor windows. The Goldsmiths' Company received its first royal charter in 1327 and is one of the Great Twelve Livery Companies of the City of London that include among their number the Mercers, Grocers, Drapers, Fishmongers, and Haberdashers. All these companies have their roots in medieval times when it was their responsibility to train craftsmen and to maintain the quality and standards of their trades. Nowadays the Goldsmiths' Company also carries out many charitable activities

Goldsmiths' Hall. (© A. McMurdo)

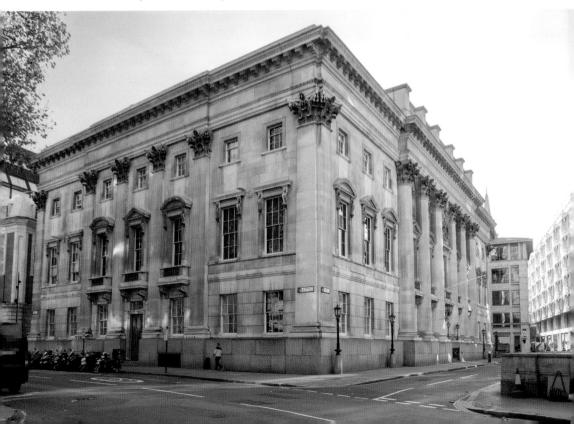

and sponsors students, provides bursaries and supports apprenticeships. Its mission is 'to advance, maintain and develop art, craft, design and artisan skills related to goldsmithing'.

The interior of the building is simply palatial, befitting the status of such an old and important organisation. Its Staircase Hall is the most opulent of entrance halls, full of marble and dominated by an imperial staircase that divides beneath a magnificent moulded and gilded dome. Upstairs, the lavish livery hall, decked out in red and gold, is highly ornate with a richly decorated ceiling. It is further

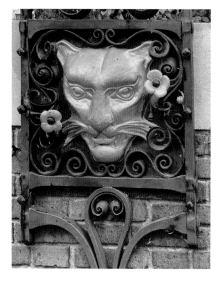

*Left*: Leopard head symbol, Goldsmiths' Hall. (© A. McMurdo)

*Below*: Goldsmiths' Hall. (© A. McMurdo)

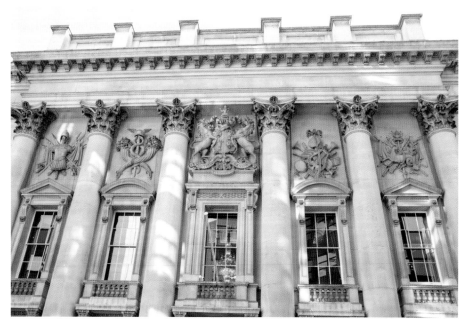

embellished by a group of stunning chandeliers and Corinthian columns of scagliola. No wonder that Netflix chose to film parts of the TV series *The Crown* in this room, using it as a substitute for Buckingham Palace.

Although the building rarely opens to the public, if you manage to visit the annual fair or attend an open day be sure to see the Bowes Cup, believed to have been used at Elizabeth I's coronation banquet in 1558 and one of the company's most treasured possessions.

The Goldsmiths' Company continues to carry sole responsibility for hallmarking precious gold and silver items, marking them with a leopard's head, a symbol that is prominent both within and outside the premises.

*Station: St Paul's*                                                        *www.thegoldsmiths.co.uk*

## 7. Guildhall and Guildhall Art Gallery, Gresham Street, EC2

The Guildhall has been the seat of government for the City of London for more than 800 years. It is the City's Town Hall and is where its elected assembly, the Court of Common Council meets. Hosting events such as coronation and jubilee lunches and banquets, the building is also where elections for the Lord Mayor and sheriffs are held. The Guildhall was constructed in 1428, and remarkably its fifteenth-century walls and crypt have weathered fire (1666) and wartime bombing (1941), making it the only surviving secular stone building in the Square

The Guildhall and Guildhall Art Gallery. (© A. McMurdo)

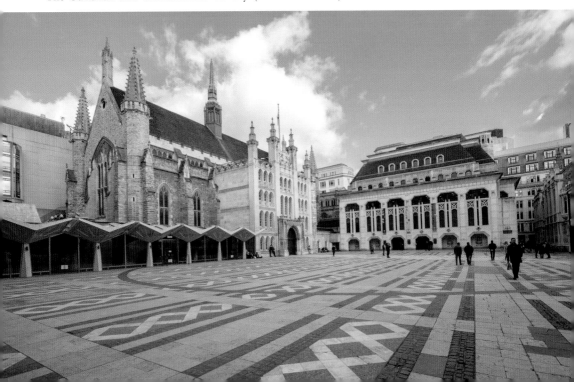

Mile. The splendid late eighteenth-century porch bearing the City's coat of arms is the main ceremonial entrance today.

Inside, the vast great hall is one of the largest civic halls in England. Under its stunning oak-panelled roof the hall is decked out with banners of the twelve Great Livery Companies, monuments of politicians and national heroes and a minstrel's gallery. It was here in the sixteenth century that the trials of Lady Jane Grey, the nine-day queen, and Archbishop Cranmer took place.

Beneath the great hall is the delightfully atmospheric undercroft that is nowadays used as an events space. It is divided into two crypts, one of which (the west side) is said to pre-date the great hall and was only rediscovered in the 1970s.

To the east of the Guildhall, in neo-Gothic style, is the Guildhall Art Gallery. This houses the City of London's art collection of sculpture, paintings and drawings and displays about 250 works at any one time. The gallery is renowned for its fabulous collection of Victorian art and includes paintings by the Pre-Raphaelite artists Rossetti and Millais, as well as works of Lord Leighton. John Singleton Copley's enormous painting *The Defeat of the Floating Batteries at Gibraltar* takes prize position in the main gallery, extending over two floors.

In 1987, archaeological investigation in Guildhall Yard unearthed part of a Roman amphitheatre, which is now on display within the gallery's basement. Tours explaining the site and its activities such as gladiatorial combats take place on Tuesday, Friday and weekends. The art gallery is free and is open daily 10.30–16.00.

*Stations: Bank, St Paul's*                    *www.cityoflondon.gov.uk*

The crypt, Guildhall. (© A. McMurdo)

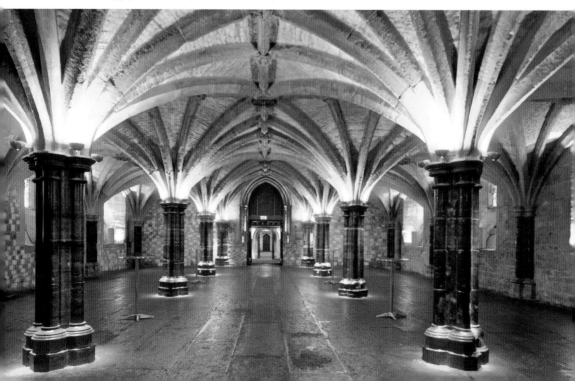

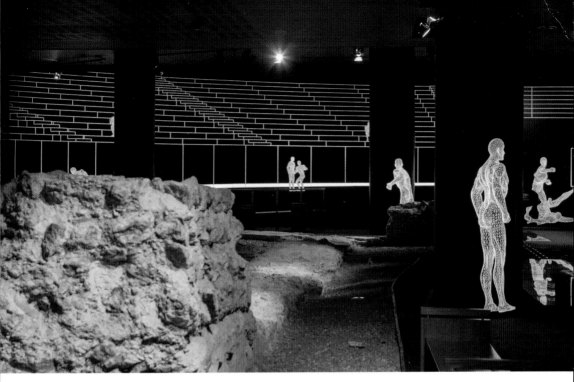

Roman amphitheatre. (© A. McMurdo)

## 8. St Sepulchre without Newgate Church, Holborn Viaduct, EC1

St Sepulchre's sits on a prominent site at the junction of Holborn Viaduct and Newgate Street. Built in 1450 just outside the City's gates it occupies a large site and today is the largest parish church within the City. It was rebuilt following the Great Fire in 1666 and has undergone many alterations over the centuries so now exhibits a complete medley of architectural styles.

Until 1902 Newgate Prison was sited directly opposite, and the church has many gruesome associations with the gaol. From the early seventeenth century it was the habit for its priests to ring a bell at midnight outside the cells of prisoners awaiting execution and recite the following:

> All you that in the condemned hole do lie,
> Prepare you for tomorrow you shall die
> Watch all, and pray, the hour is drawing near
> That you before the Almighty must appear.
>
> Examine well yourselves, in time repent,
> That you may not to eternal flames be sent.
> And when St Sepulchre's bells in the morning tolls,
> The Lord above have mercy on your souls.

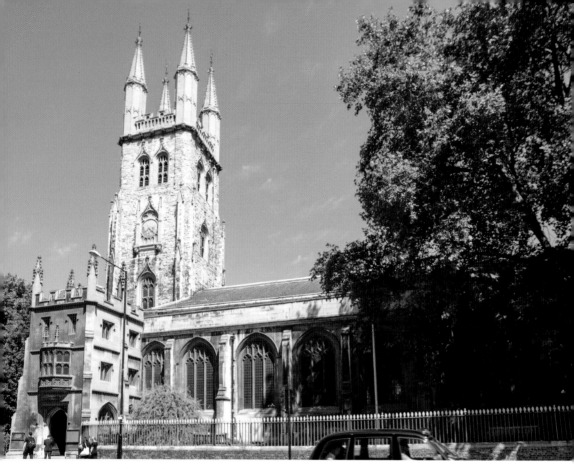

St Sepulchre without Newgate Church. (© A. McMurdo)

St Sepulchre's has always been famous for its music – Handel, Mendelssohn and Samuel Wesley all played its very fine 1670 Renatus Harris organ that sits beside the Musician's Chapel. The latter was built as a memorial to Sir Henry Wood (1869–1944), the founder of the annual Proms concerts. His ashes are interred here and a wonderful memorial window containing scenes from his life was unveiled following his death. The chapel is full of furnishings that remember musicians, including a window dedicated to the soprano Dame Nellie Melba.

Although there are many celebrated names connected with St Sepulchre's, possibly the most flamboyant of them is Captain John Smith (1580–1631), a former worshipper and seventeenth-century explorer who sailed to the New World in 1606. Smith had many adventures there and is said to have only escaped death through the intervention of the native princess Pocahontas. He became the first governor of Virginia but later returned to London and was buried within the church. Other interments include Elizabeth I's tutor Roger Ascham and the Reformation martyr John Rogers, who was burnt at the stake in 1555.

*Stations: St Paul's, City Thameslink*                    *www.hsl.church*

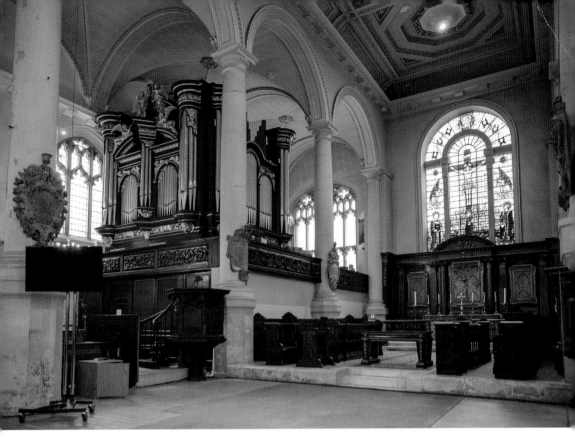

St Sepulchre without Newgate Church. (© A. McMurdo)

## 9. Prince Henry's Room, No. 17 Fleet Street, EC4

No. 17 Fleet Street, with its black-and-white half-timbered façade and wonderful leaded windows, is quite unlike the buildings surrounding it. It is a splendid Tudor house that sits above the entrance to Inner Temple and is one of few pre-1666 buildings that remain in the City. Seventeenth-century London was full of narrow streets with houses built dangerously close to one other and subject to frequent fires. The 1666 Great Fire of London was fed by a strong easterly wind, resulting in the destruction of thousands of buildings including churches, livery halls and some 80 per cent of the City's housing.

Prince Henry's Room stands on land once owned by the Knights Templar but in the early 1600s a tavern, The Prince's Arms, was built on the site. Construction coincided with the investiture of James I's son Henry as Prince of Wales, which led to speculation that the building was a royal residence, although this has never been proven. Certainly, the room's magnificent Jacobean plaster ceiling bearing the Prince of Wales' feathers and the letters 'PH' might lend credence to the belief.

Nowadays, Prince Henry's Room is a Grade II* listed building and owned by the City of London.

*Station: Temple*     *www.cityoflondon.gov.uk*

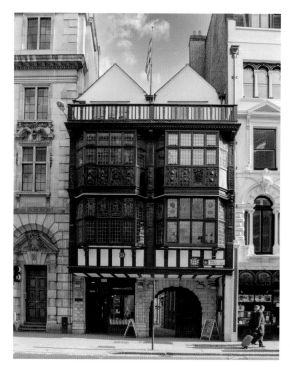

Prince Henry's Room.
(© A. McMurdo)

## 10. Temple Bar Gate and Paternoster Square, EC4

The arrival of Temple Bar Gate as the entrance to Paternoster Square in 2004 heralded its return to the Square Mile following more than a century of exile in Hertfordshire. Historically the gateway was sited at the junction of Strand and Fleet Street and acted as a boundary gate between the City of Westminster and the City of London. Today, this spot is marked by the Victorian Temple Bar Memorial that stands in the middle of the road opposite the Royal Courts of Justice.

Temple Bar Gate is a wonderful baroque public building erected in the 1670s when London was recovering from the aftermath of the Great Fire. Made of Portland stone, it consists of three archways and is adorned with statues and sculptures of royal personages and beasts and a pediment displaying a fine coat of arms. The gateway is attributed to the great architect Sir Christopher Wren, who at the time was Surveyor to the King's Works and held overall responsibility for royal building projects. Wren's association with the building and its architectural style have resulted in its Grade I listed status. It is moreover the City's only historic gateway to have survived from the period.

Throughout its existence Temple Bar Gate played a major part in the ceremony of the City. For more than 200 years monarchs halted beside the gateway to ask the Lord Mayor for leave to enter the City, and in turn were presented with the Sword of State by him as a symbol of the City's allegiance. Here too the heads of traitors would be displayed on iron spikes at the top of the gateway.

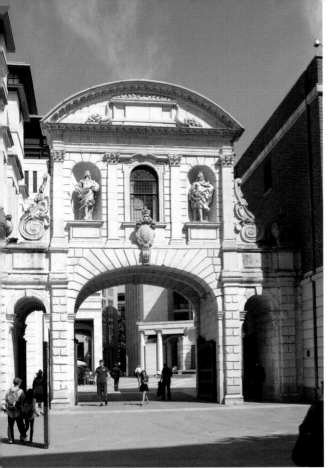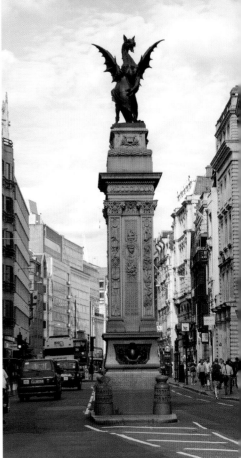

*Above left*: Temple Bar Gate, Paternoster Square. (© A. McMurdo)

*Above right*: Temple Bar memorial, Fleet Street. (© A. McMurdo)

The gateway was dismantled in the 1870s and was later erected at Theobold's Park owned by the brewer and politician, Sir Henry Bruce Meux. A century later the Temple Bar Trust was established to return the now decaying gateway back to its original London base and to restore it to its previous glory. Its final home beside St Paul's Cathedral and the newly developed Paternoster Square (that houses the London Stock Exchange and many financial organisations) is a fine resting place for the structure.

*Station: St Paul's*                                    *www.thetemplebar.info*

## 11. The Monument, Fish Street Hill, EC3

The Monument is not only the tallest freestanding stone column in the world, but it is also a wonderful tribute to one of London's greatest misfortunes, the Great Fire of London 1666. Built between 1671 and 1677 the Doric Portland stone pillar with its stunning gilded orb was designed by Sir Christopher Wren and Robert Hooke. It serves as a memorial both to the devastation caused by the

fire and to the ensuing rebuilding of the City of London. The structure measures 61 metres in height (202 feet) – exactly the distance it stands from the outbreak of the fire in September 1666 in a baker's premises on Pudding Lane.

At street level the column sits on an imposing pedestal with dragons at each corner. Three panels display Latin inscriptions: the destruction caused by the fire is recorded on the north side, London's restoration is related on the south side, while the east section provides details of the mayors during the construction of the Monument. The west panel is a bas-relief that contains an allegorical sculpture designed by Caius Gabriel Cibber and shows the king, Charles II, consoling the ruined city, signified by the female figure. Looking unkempt, the figure is seated on the ruins with her head drooping. Behind her is Time, identified by his baldness and wings, who is slowly raising her up. Other figures include goddesses in the clouds who represent Peace and Plenty as well as the king and his brother James, the Duke of York, overseeing the disaster, who appear in Roman costume. Burning houses are depicted above the female figure's head.

Wren and Hooke's design included a basement that was to serve as an underground laboratory for scientific experiments. They intended to use the structure as a giant vertical zenith telescope to measure the movement of the stars

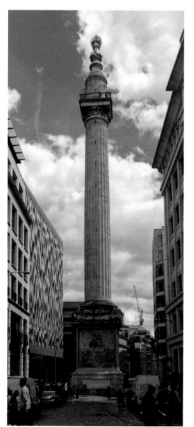

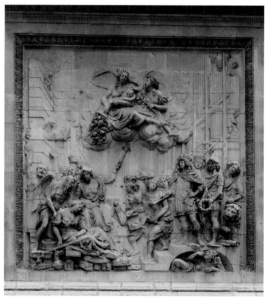

*Above*: Allegorical sculpture on the Monument. (© A. McMurdo)

*Left*: The Monument. (© A. McMurdo)

and earth, but unfortunately vibrations from the surrounding traffic interfered with their work. This forced them to transfer their research to the newly completed Royal Observatory at Greenwich.

Visitors can climb the Monument's 311 steps up to a viewing gallery from where wonderful views of the City and the Monument's golden orb can be fully appreciated.

*Station: Monument*                    *www.themonument.org.uk*

## 12. Church of St Stephen Walbrook, No. 39 Walbrook, EC4

This fabulous church is indisputably one of the City's hidden jewels and an excellent example of the brilliance of Sir Christopher Wren. Generally considered to be the prototype of Wren's masterpiece, St Paul's Cathedral, St Stephen Walbrook is however designed on a much smaller scale.

It was built between 1672 and 1687 and has a somewhat plain brick and ashlar exterior with a copper-roofed dome, a lantern and an open baroque steeple. Yet the interior, reached via an entrance staircase and porch, is simply breathtaking. One enters a perfectly proportioned room full of rectangles, circles and squares that demonstrate both Wren's mathematical background and his design genius. The church's clear windows along with its ceiling lantern provide a remarkably light space, making it appear both taller and larger than it is. The wood panelled walls, pulpit, organ case, reredos and wall memorials all add to its splendour, but the church's *chef-d'oevre* is undeniably its central dome. Decorated with exquisite carvings and surrounded by rows of Corinthian columns, it is a true focal point.

Sitting directly beneath the dome is a circular marble travertine altar created by the sculptor Henry Moore. Its unveiling led to much controversy as its design (rather like a Camembert cheese) was deemed unsuitable by some for an ecclesiastical building. Fortunately, the matter was resolved, and the highly distinctive altar remains a major feature of the church.

Several famous names are associated with St Stephen Walbrook. The playwright and architect Sir John Vanbrugh (1664–1726) lies buried beneath the church floor and Dr Chad Varah, a rector in the 1950s who founded the Samaritans here. His telephone helpline for people who were suicidal or in despair was the first of its type to be set up in this country and the original Samaritans telephone with its number MAN (Mansion House) 9000 is still displayed inside the church.

Today the church holds regular services here as well as free lunchtime musical recitals. It is an utter delight to sit and listen to the concerts away from the noise of the City beyond while enjoying St Stephen Walbrook's peaceful and very beautiful surroundings.

*Station: Bank*                    *www.ststephenwalbrook.net*

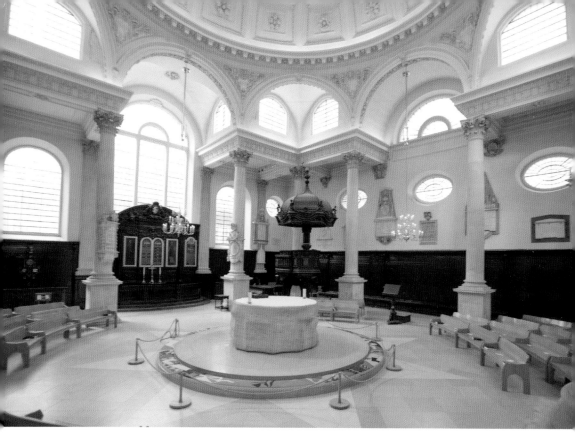

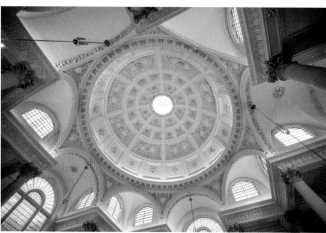

*Above and left*:
Interior of St Stephen
Walbrook Church.
(© A. McMurdo)

13. St Bride's Church, Fleet Street, EC4

St Bride's is generally referred to as the 'Journalist's Church' and has been
associated with the printing industry for more than 500 years since Wynkyn
de Worde first set up his printing press here. For at least 200 years Fleet Street
operated as the heart of the newspaper industry and was known as 'The Street of

Ink', but when new technology emerged in the 1980s the newspapers moved out and transferred their businesses to Docklands. Nonetheless, St Bride's link with the industry is strong and weddings, funerals and memorial services of journalists take place here regularly.

The church, the eighth on this site, gets its name from a devout fifth-century Irish saint known for her kindness and hospitality. The present building was designed after the Great Fire by Sir Christopher Wren and possesses one of the finest city church interiors with double Tuscan columns supporting a barrel vault (although what one sees today is a reconstruction of Wren's original mastery due to bomb damage during the Second World War). The wartime devastation fortunately revealed the remains of some of the earlier Norman and Saxon churches, a Roman pavement, and a medieval chapel, which are now all exhibited in the crypt.

The church's tall and unusual spire with its five diminishing octagonal arcades bears a great resemblance to a cake with several layered tiers. In fact, it is said that in the mid-eighteenth century local pastry cook William Rich modelled his daughter's wedding cake on the spire, inspiring countless others to follow suit – a practice that continues to this day. The spire is also the subject of another story

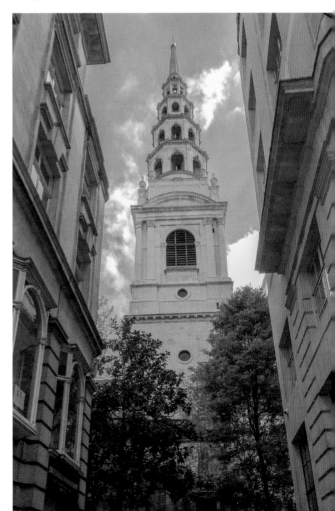

The exterior of St Bride's Church.
(© A. McMurdo)

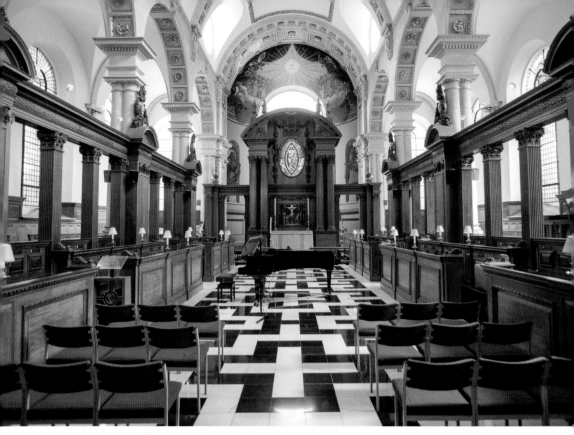

The interior of St Bride's Church. (© A. McMurdo)

involving the diplomat and scientist Benjamin Franklin: it was he who, following a lightning strike, invented a sharp-ended lightning conductor for the spire, although he came into conflict with the king who preferred a blunt-ended device. Franklin ultimately won the debate when 'the blunt, honest king George' gave way to the 'sharp-witted American'.

As with many of the City churches St Bride's cherishes its musical reputation. Its excellent professional choir is renowned internationally and many of its singers are famous in their own right.

*Station: Blackfriars*                                                                  *www.stbrides.com*

## 14. St Paul's Cathedral, St Paul's Churchyard, EC4

Known as the 'Nation's Church', St Paul's Cathedral has been the setting for both joyous and sad occasions including Thanksgiving and memorial services, jubilee celebrations and funerals to national heroes. Although royal marriages customarily take place at Westminster Abbey, the wedding of Prince Charles to Lady Diana Spencer was celebrated here in 1981 and seen on television screens by a global audience of more than 750 million.

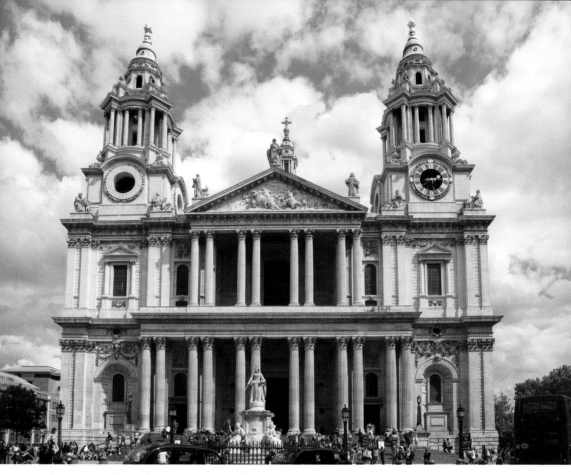

*Above*: St Paul's Cathedral, Ludgate Hill. (© A. McMurdo)

*Below*: St Paul's Cathedral from the Millennium Bridge. (© A. McMurdo)

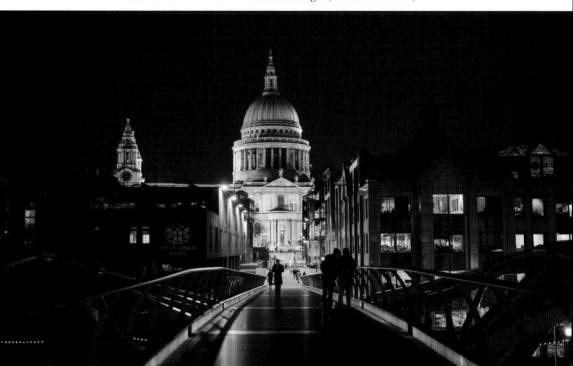

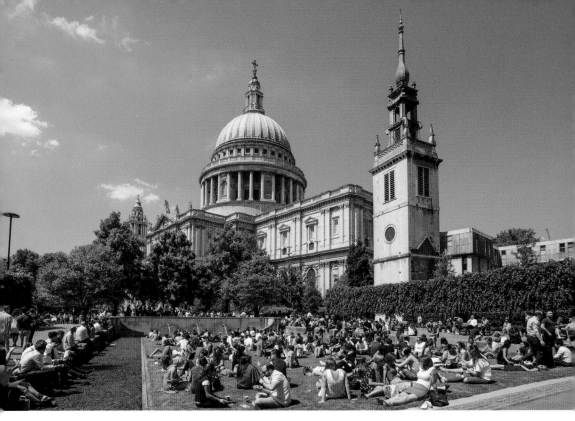

Jubilee Gardens, St Paul's Cathedral. (© A. McMurdo)

The present cathedral is the fifth on the site, replacing the huge eleventh-century Gothic cathedral that had previously dominated the landscape. When it burnt down in 1666 Sir Christopher Wren was commissioned to design its replacement, the first Anglican cathedral to be erected since the Reformation of the 1530s.

It was a massive project and construction took thirty-five years (1675–1710) during the course of the reign of five monarchs. Over this long period Wren managed to alter the original plans so that the final cathedral was embellished by an enormous dome, only second in size to that of St Peter's in Rome. Until this time spires had been the norm in ecclesiastical buildings so some controversy was caused by this new and alien style of baroque architecture. Nonetheless, the magnificence of the cathedral was not questioned and Wren's choice of craftsmen – Tijou for the ironwork, Thornhill for his dome decoration, Gibbons for the carved woodwork and the Strong brothers for the masonry – was praised by all. With clear windows and little statuary St Paul's appeared very bright and spacious until coloured ceiling mosaics, monuments and stained-glass windows were introduced in the nineteenth and twentieth centuries. The latter were added after the Second World War to the newly established American Chapel built by Britain to show its gratitude for America's wartime aid.

The crypt downstairs holds Wren's modest grave as well as plaques, tombs, memorials to famous people of the arts and sciences and to Britain's naval and military heroes – the most important of whom are the Duke of Wellington and Horatio,

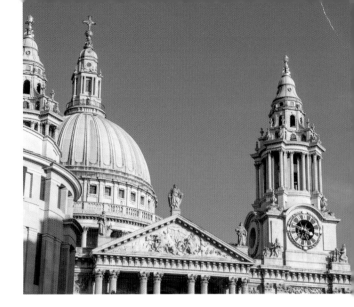

Baroque exterior of St Paul's Cathedral. (© A. McMurdo)

Admiral Lord Nelson. Nelson's tomb lies directly beneath Wren's magnificent dome that is both a wonderful feat of engineering and Wren's true magnum opus.

*Station: St Paul's, City Thameslink*                    *www.stpauls.co.uk*

## 15. Vintners' Hall, No. 68 Upper Thames Street, EC4

Located on the edge of Southwark Bridge in Lower Thames Street the Vintners' Company received its first royal charter in 1363. It was an immensely important and influential organisation at a time when wine and wool were the country's chief trades. The Company operated as a guild setting standards, fixing the price of wine, and looking after the welfare of its members through its benevolent and educational activities. In 1515, in recognition of the Vintner Company's status the Lord Mayor placed it as eleventh in the order of precedence of the Great Twelve Livery Companies.

However, over time the company's importance waned as its privileges were restricted by successive monarchs and due to financial losses incurred following the Great Fire of London 1666. Yet, by careful management of its estates and through its many charitable works it later regained much of its reputation and was granted a new charter in 1973.

The Vintners' Company has existed at this location since the Middle Ages but the present building dates to the 1670s and many of its original features, including artworks, woodwork and furniture, are still displayed in its grand and ornate rooms. The magnificent seventeenth-century Livery Hall is in constant use as a venue for banquets, conferences, and charitable fund-raising events.

Nowadays, the company supports many educational projects and bestows sizable grants to charities dealing with the social consequences of alcohol abuse. Through the Vintners' Wine and Spirit Education Trust and the Institute of

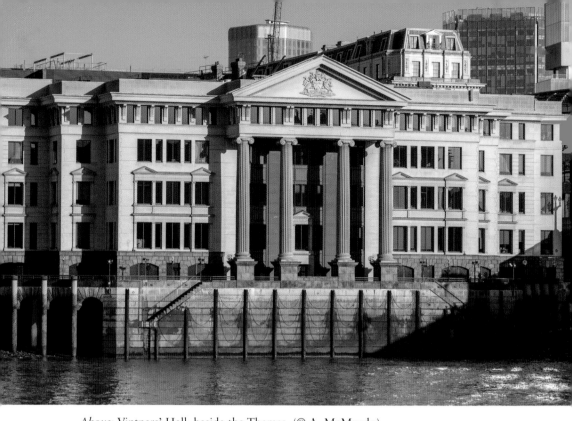

*Above*: Vintners' Hall, beside the Thames. (© A. McMurdo)

*Below*: Court Room, Vintners' Hall. (© A. McMurdo)

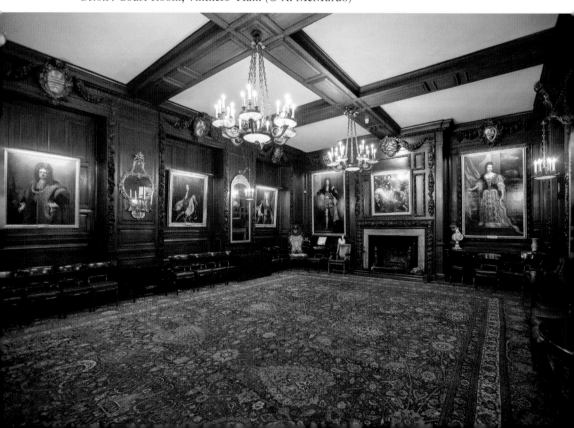

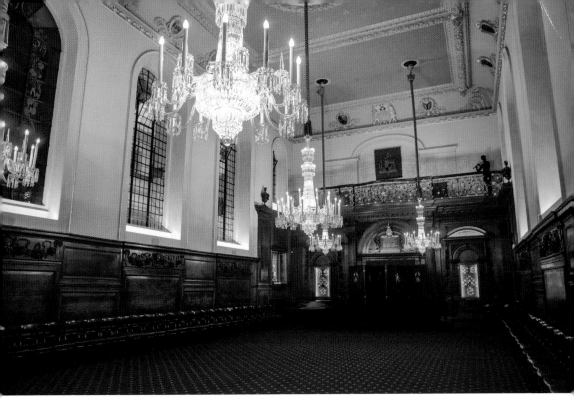

Livery Hall, Vintners' Hall. (© A. McMurdo)

Masters of Wine it supports its members to grow professionally and to acquire qualifications that are today internationally recognised.

No one quite knows when the Vintners' association with swans began, but their right to own swans is said to be 'by prescription' – meaning that the right has been exercised for so long that it has never been challenged. Every July the company is involved in 'Swan Upping' when it checks both the numbers and health of the swans on the River Thames. A public sculpture, *Swan Marker and Barge Master*, in traditional dress, stands outside the Vintners' Company church, St James Garlickhythe, at the southern end of Garlick Hill.

*Stations: Mansion House, Cannon Street*                    *www.vintnershall.co.uk*

## 16. Christ Church Newgate Street and Christ's Hospital, EC1

Following wartime bombing and devastation Christ Church Newgate Street was reinvented as a city garden in the 1980s and is now a popular haunt of local workers and visitors. In transforming the site the Corporation of London took great care to emulate the outline of the severely damaged seventeenth-century Wren church, and if you look carefully you can see how the rose garden represents the former church nave – the paths the aisles, the box hedging the pews, and the pergolas its piers. Somehow the garden's landscapers managed to provide a

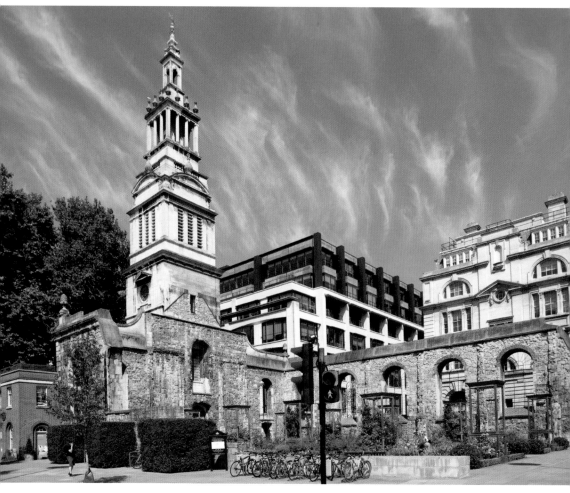

*Above and below left*: Christ Church Newgate Street. (© A. McMurdo)

*Below right*: Sculpture of Christ's Hospital at Christ Church Newgate Street. (© A. McMurdo)

wonderfully spiritual and peaceful sanctuary despite its location in the heart of a busy road network.

So badly gutted was the church that only its tower, the north wall and a part of the south wall were left in situ after the war. Fortunately, in 1960 the tower underwent a meticulous restoration by Lord Mottistone who returned it to its previous splendour. It is still considered to be one of Wren's finest towers, and stands out for its three square stages. The bottom stage consists of a louvred belfry, the stage above is enclosed by a colonnade and surmounted by twelve large urns, and rising from this is an elegant square spire with a vase and ball finial on top.

Christ Church was erected after the Great Fire of 1666 to replace an earlier church that had been part of the Franciscan monastery (Greyfriars) here until it closed down in the 1530s. It was actually built on land that had previously served as the monastery's chancel. In 1552, Christ's Hospital, a charity school, was established on the site and the two institutions existed side by side until 1902 when Christ's Hospital moved out of London. From the time it was founded the school provided education to orphaned children of poor Londoners who were immediately identified by their colourful uniform comprising a long blue coat, belted at the waist, yellow socks and white neck bands (clothing that the boys and girls still wear today). An excellent bronze sculpture depicting the pupils now exists on the garden's southern edge, the work of the renowned sculptor, Andrew Brown.

*Stations: St Pauls, City Thameslink*                                  *www.cityoflondon.gov.uk*

## 17. Dr Johnson's House, No. 17 Gough Square, EC4

Located behind Fleet Street, Dr Johnson's house is set amid a maze of courts and alleyways in Gough Square. It is a handsome five-storey late seventeenth-century townhouse, originally the home of a city merchant. Dr Samuel Johnson (1709–84) lived here from 1748 to 1759 and it was where he compiled his comprehensive dictionary of the English language.

Samuel Johnson was a devout Anglican and greatly opposed slavery. After his wife's death he employed a former Caribbean slave as his manservant, and it was to him that he left his estate when he died in 1784.

The house was purchased in 1911 by the politician and newspaper magnate Cecil Harmsworth, who restored and refurbished the building before opening it as a museum. Visitors today can wander around the beautiful Georgian interiors marvelling at the fine panelled rooms and period furnishings. The museum contains objects relating to the essayist and regularly offers curators' talks, concerts, staged performances and special exhibitions.

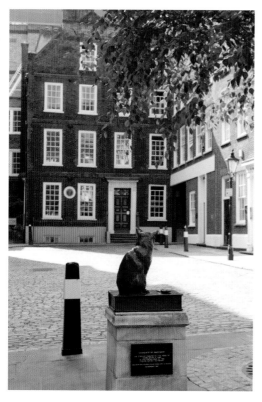

Dr Johnson's house. (© A. McMurdo)

In the courtyard outside the house look out for the bronze statue of Dr Johnson's cat, Hodge. He is seated beside a couple of empty oyster shells on the top of his owner's dictionary and the inscription below reads: 'A very fine cat indeed.'

*Stations: Chancery Lane, Blackfriars*          *www.drjohnsonshouse.org*

## 18. Ye Olde Cheshire Cheese, No. 145 Fleet Street, EC4

This is one of Fleet Street's most popular taverns that captivates visitors with its wonderful atmosphere of bygone days. Ye Olde Cheshire Cheese is easily identified on the street for its dark façade embellished by its ground-floor windows, ornate pilasters and a hanging lamp inscribed with the date '1667' – the year that the pub was rebuilt after the Great Fire of London. In its 350-year existence it has undergone many alterations but fortunately the tavern has lost little of its original character.

The main entrance is found in the alleyway running beside the pub, Wine Office Court, leading one to assume that the pub will be small and pokey inside. However, it is unusually spacious, filled with a warren of rooms set on a number of floors, each offering secluded areas and cosy corners. The wood panelling and

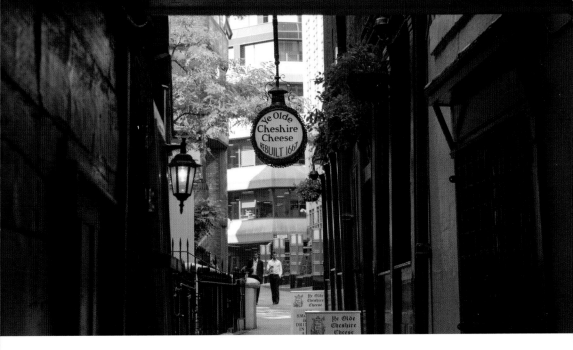

*Above*: Entrance to Ye Olde Cheshire Cheese. (© A. McMurdo)

*Right*: Ye Olde Cheshire Cheese, Wine Office Court. (© A. McMurdo)

# WINE OFFICE COURT

"SIR" said D$^r$ Johnson "If you wish to have a just notion of the magnitude of this great City you must not be satisfied with seeing its great streets and squares but must survey the innumerable little lanes and courts ....................................

This Court takes it's name from the Excise Office which was here up to 1665. VOLTAIRE came, and, says tradition, CONGREVE and POPE . D$^r$ JOHNSON lived in Gough Square *(End of the Court on the left)* and finished his Great Dictionary there in 1755. OLIVER GOLDSMITH lived at N$^o$ 6, where he partly wrote "The Vicar of Wakefield" and Johnson saved him from eviction by selling the book for him....................

Here came Johnson's friends. REYNOLDS, GIBBON, GARRICK, D$^r$ BURNEY, BOSWELL and others of his circle. In the 19$^{th}$ C. came CARLYLE, MACAULAY, TENNYSON DICKENS, *(who mentions the Court in "A Tale of Two Cities")* FORSTER, HOOD, THACKERAY, CRUIKSHANK, LEECH and WILKIE COLLINS. More recently came MARK TWAIN, THEODORE ROOSEVELT, CONAN DOYLE . BEERBOHM CHESTERTON, DOWSON, LE GALETENE, SYMONS YEATS— and a host of others in search of D$^r$ Johnson, or "The Cheese"

furniture of the interior is dark, but the open fires are bright and cheery and make for a welcoming ambiance.

Ye Old Cheshire Cheese has always been patronised by the literati and a list of their names appears outside the building. In Fleet Street's heyday it was also where journalists enjoyed many a pint while discussing major issues of the day.

*Stations: Blackfriars, City Thameslink*

## 19. Bevis Marks Synagogue, No. 4 Heneage Lane, EC3

Bevis Marks is the only synagogue left standing in the Square Mile today and services for its Sephardi community that arrived in London from Portugal and Spain in the mid-seventeenth century have been held within the building ever since. The synagogue's position within the Anglo-Jewry community is and has always been of the utmost importance. Throughout its 300-year history it has hosted many ceremonial and state occasions. It is also where special services to commemorate and honour world leaders and those in public office have taken place.

Erected in 1701, Bevis Marks was constructed by Joseph Avis, a Quaker carpenter, in the style of a simple Wren church. Its exterior, set within a courtyard, is unassuming: a plain, red-brick box with two rows of large clear windows giving it an austere appearance. In complete contrast the interior, said to be influenced by the decoration of the late seventeenth-century Portuguese Great Synagogue in Amsterdam, is splendidly furnished. This is particularly demonstrated by the

Entrance to Bevis Marks Synagogue.
(© A. McMurdo)

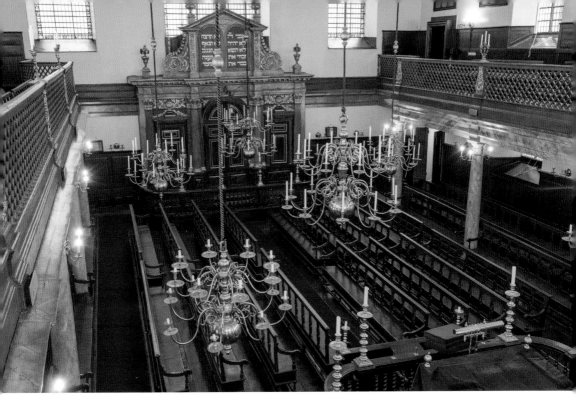

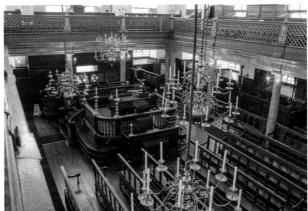

*Above and right*: Bevis Marks Synagogue. (© A. McMurdo)

synagogue's beautiful dark wood benches, its richly coloured carved Ark and its large gallery (from where one gets an excellent view of the entire building). Many of Bevis Marks' furnishings are symbolic: the twelve marble pillars supporting the gallery denote the twelve tribes of Israel, the ten brass candlesticks represent the Ten Commandments, while the seven chandeliers relate to the seven days of the week (the central chandelier symbolising the Sabbath). If you are lucky enough to be invited to a wedding here you will also experience the twinkling lights of its myriad of candles, making for a truly wonderful atmosphere.

At the time of writing Bevis Marks has embarked upon a project to restore its annexe so that the synagogue's outstanding collection of ritual silver and many

artefacts can be displayed in its undercroft. It has received a grant through the Heritage Lottery Fund which will help the synagogue to establish a permanent exhibition space to interpret the stories behind Bevis Marks, its original community and the design of the building. The scheme also intends to provide new educational facilities, a shop and café. See sephardi.org.uk for details of opening hours.

*Station: Aldgate*                                              *www.sephardi.org.uk*

## 20. Bank of England, Threadneedle Street, EC2

The Bank of England occupies an entire block on Threadneedle Street and sits alongside the Royal Exchange. It owes its design to two distinguished architects, Sir John Soane (1753–1837) and Sir Herbert Baker (1862–1946) and in many respects has the appearance of a fortress due to its continuous windowless wall. Its main entrance is imposing, featuring large columns and a substantial pediment containing the figure of Britannia at its centre. Founded in 1694 by the Scotsman and leading City banker and trader William Paterson (1658–1719), the bank was set up to help fund and raise much needed capital for war against the French. A permanent home was built on this site in 1734 but the institution quickly outgrew its premises, which led to Sir John Soane's appointment as official architect and surveyor, a task he carried out for the next forty-five years. In addition to enlarging the original building he introduced the curtain wall to increase security around the premises and was responsible for its interior design and decoration. The bank was redesigned in the 1920s by Sir Herbert Baker, at

*Below and opposite below*: The Bank of England. (© A. McMurdo)

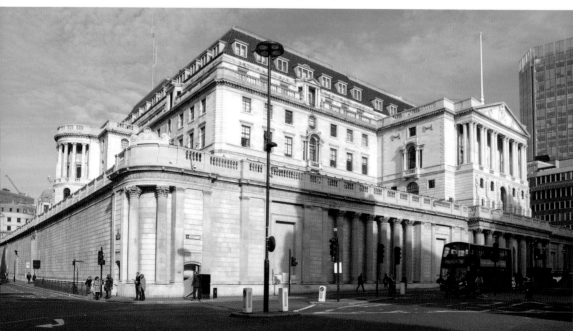

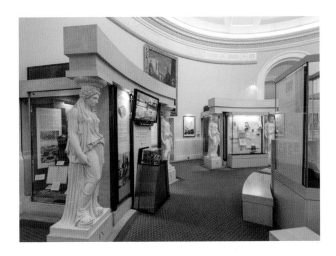

The Bank of
England Museum.
(© A. McMurdo)

which time much of the earlier building was demolished and more floors were
added both above and below ground resulting in what we see today.

To get an idea of the interior of Soane's bank you can visit its small but very
good museum on Bartholomew Lane. Here, in a reconstruction of the Stocks
Office, permanent and temporary displays describe the bank's history and
development and explain about how the bank works to protect the financial
system from economic shocks. Visitors to the galleries can handle a genuine
gold bar and learn about the evolution of bank notes, with particular emphasis
on modern technology. There is also a cabinet dedicated to the author Kenneth
Grahame (famous for *The Wind in the Willows*), who worked at the bank for
almost thirty years.

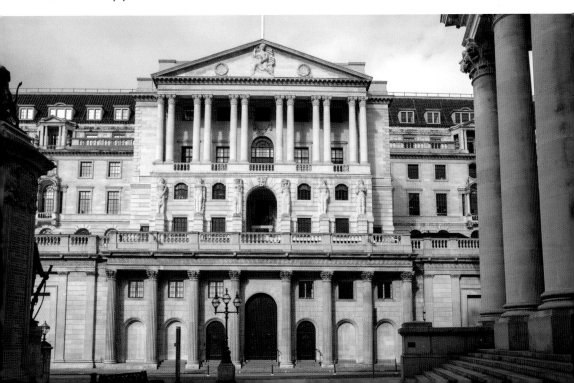

The Bank of England's role is of great significance acting both as the government's banker and the printer of bank notes. Moreover, it is the guardian of currency, holds the nation's gold and foreign exchange currency reserve and is responsible for setting interest rates.

*Station: Bank*                                              *www.bankofengland.co.uk*

### 21. Mansion House, Walbrook, EC4

Mansion House is a wonderful example of the talent of George Dance the Elder (1695–1768) as an architect. Built in 1752 to be the official home for the Lord Mayor of the City of London, Dance's love of Palladian architecture is demonstrated both externally and within Mansion House itself. The house stands on the corner of Bank Junction and is easy to identify for its raised portico, blue railings, and grand Corinthian columns. Four storeys high, it contains ornate public rooms used for formal entertainment as well as private apartments on the third floor for the Lord Mayor and immediate family while in office. The interior boasts a stunning staircase, much statuary and intricate, decorative plasterwork.

Mansion House. (© A. McMurdo)

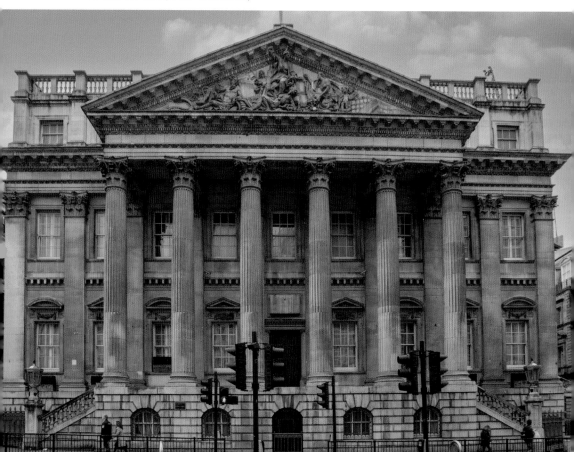

Downstairs in the basement Dance placed eleven holding cells and a courtroom over which the Lord Mayor presided when undertaking his role as Chief Magistrate of the City of London, and where he would mete out justice. Neither the courtroom nor the cells are however in usage today.

Two spectacularly ornate rooms fill the first floor – namely the ballroom and the Egyptian Hall. The latter, with its splendid towering columns, high vaulted ceiling and wealth of marble statues, surprisingly contains no Egyptian decoration and would be better named the Roman Hall, for it is actually based on Roman buildings in Egypt. It is in these lavish rooms that the Lord Mayor entertains heads of state (on behalf of the government), visiting dignitaries and people from the business world as well as senior politicians. The Egyptian Hall is also a venue for banquets, conferences, livery and civic activities, and where the Chancellor of the Exchequer's annual speech about the state of the British economy is delivered.

Mansion House is especially noted for its outstanding Anglo-Dutch collection of Dutch and Flemish seventeenth-century paintings that includes works by the artists Pieter de Hooch, Jan Steen, Aelbert Cuyp, Frans Hals and Nicholas Maes. Tours of the main building regularly take place on Tuesday afternoons. Information about this and tours of the art collection can be found on www.cityoflondon.gov.uk.

*Stations: Bank, Cannon Street*                *www.cityoflondon.gov.uk*

## 22. Custom House and Old Billingsgate, Lower Thames Street, EC3

The River Thames has been London's main artery for hundreds of years. It is an exceptionally busy highway filled with vessels ferrying passengers and transporting goods into and out of London. From Roman times wines, pottery and glassware were brought along the river to the capital and over time the range of products expanded to include building materials, foodstuffs and luxury goods from every corner of the globe. Successive monarchs imposed taxes on the imported goods and these duties were collected at the Custom House.

Today's building, nestled between Lower Thames Street and the Thames, is the sixth to exist on the site. With its exceedingly long river frontage and neoclassical architecture, it is one of the riverside's most impressive buildings. Dating to 1817 it was designed by David Laing but following a partial collapse was rebuilt in the 1820s by Sir Robert Smirke, the architect of the British Museum. The building has an array of architectural features including Ionic porticos that face the river and Doric pilasters, railings and iron-bracketed lamps on its Lower Thames Street's façade. The interior too boasts a wealth of Regency details. It is renowned for its Long Room on the first floor, which is not only exceptionally long at 58 metres (190 feet), but is even more famous for the trading activities that took place within its walls involving many merchants,

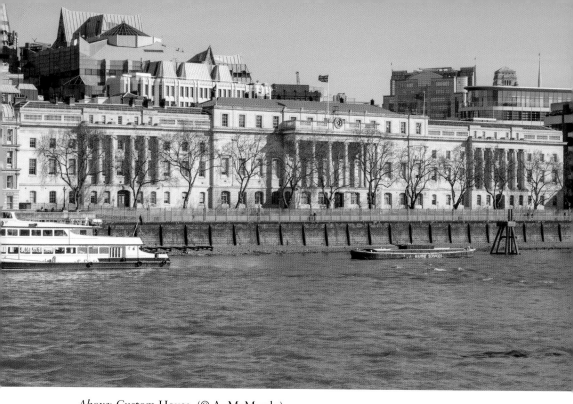

*Above*: Custom House. (© A. McMurdo)

*Below*: Old Billingsgate Market. (© A. McMurdo)

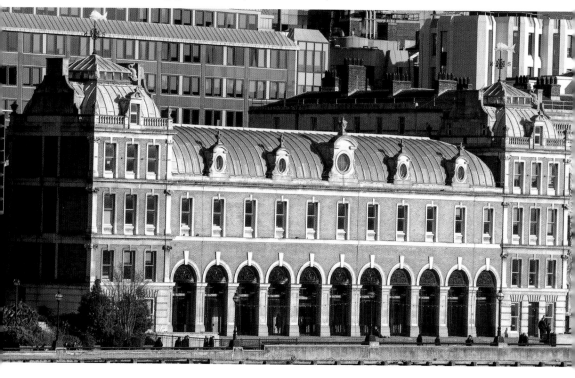

Weathervane above
Old Billingsgate.
(© A. McMurdo)

brokers, and ship captains. Recently the building has been used as a government office, but plans are afoot to convert it into a hotel. Due to Custom House's history and significance objections to the scheme have been lodged, but to date no decision has been finalised about its future.

The former Billingsgate Fish Market lies to the west of Custom House. Nowadays the building has become an entertainment hub and hosts events such as product launches and fashion shows, but for about a century the market building was a thriving centre for the fish trade alone. Designed in the 1870s by the City architect Sir Horace Jones, it is famed for its grand arcaded market hall, double-vaulted basement and cast-iron roof as well as its marvellous exterior architecture.

*Station: Monument*                                    *www.oldbillingsgate.co.uk*

## 23. The Royal Exchange, EC3

This is one of the City's most important buildings as it is here, on its front steps, that the death of the monarch is announced and the accession of the new sovereign is proclaimed. The building owes its existence to a wealthy City merchant, Sir Thomas Gresham (1519–79), who was so impressed by the Bourse in Antwerp (which allowed merchants to carry out business under cover) that he copied the idea and thus created the City's first indoor trading and shopping mall. The present building, sitting on its own island between Threadneedle Street and Cornhill, dates to 1844 and was designed by Sir William Tite (1798–1873) in the style of the Pantheon in Rome. It has a magnificent columned entrance surmounted by a triangular pediment containing sculptures of the central figure of Commerce surrounded by City merchants, showing the long relationship between the Royal Exchange and the City's commercial life.

Originally the building was fitted out with a trading floor and shops on higher levels. Nowadays, the Royal Exchange's affluent customers shop at its luxury

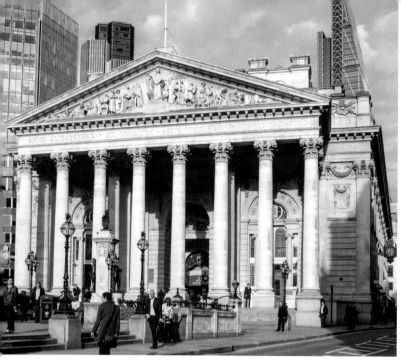

*Above*: Statue of
Sir John Gresham above
the Royal Exchange.
(© A. McMurdo)

*Left*: The Royal
Exchange.
(© A. McMurdo)

designer shops such as Tiffany & Co., Hermes and Mont Blanc or maybe dine at
The Fortnum's Bar and Restaurant or Grind Café Bar.

*Station: Bank*                                           *www.theroyalexchange.co.uk*

## 24. Smithfield Market, Grand Avenue, EC1

The market is built on what was once a swamp on the edge of the City. Throughout
its history Smithfield has been associated with blood and death: the place where in
1300s the Scottish patriot William Wallace was executed; Wat Tyler, the leader of
the Peasants' Revolt, was stabbed to death; and where witches and heretics were
killed during the Middle Ages. In the religious turmoil of the Tudor period many
Protestants and Catholics died here too, being burnt at the stake or hung, drawn
and quartered. On a lighter note, the 'Smooth Field' was also where jousting
tournaments and the annual Bartholomew Fair were held.

For more than 800 years Smithfield was home to London's main livestock
market, where cattle and sheep were slaughtered, so it is no wonder the area had
a reputation for dirt, blood and gore. The author Charles Dickens described the
market scene in *Oliver Twist*, writing: 'The ground was covered, nearly ankle-
deep, with filth and mire; a thick steam, perpetually rising from the reeking bodies
of the cattle...' The situation improved however in 1855 when the live market
moved to Islington and Smithfield became a 'dead' meat market. The decision was
then taken to provide a permanent home for the market and Sir Horace Jones,
the City's architect, was commissioned as its designer. Completed in 1868, this

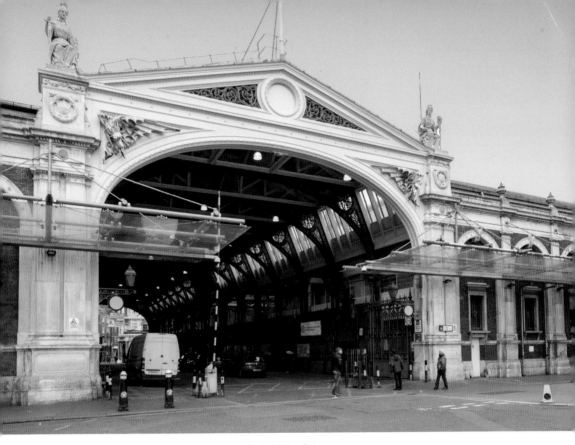

*Above*: Smithfield Market entrance. (© A. McMurdo)

*Below left*: Smithfield Market corner tower. (© A. McMurdo)

*Below right*: Interior of Smithfield Market. (© A. McMurdo)

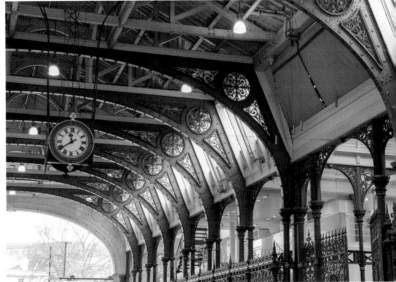

glorious Victorian structure still remains the central focus of Smithfield and is a hive of activity through the night and into the early morning. It is truly resplendent with its red-brick and white Portland stone exterior, corner towers, cast-iron gates and its wonderfully coloured ceiling supports. Its two main entrances both have large pediments above the gateways that are flanked on either side by statues representing London, Edinburgh, Dublin and Liverpool.

Smithfield is unusual in being the only wholesale market to remain in the centre of town but is shortly due to relocate to a mega-market site outside of the City. Proposals have already been put forward to utilise the market buildings as a fundamental part of the City's Culture Mile, which it hopes will rival the South Bank in future years.

*Station: Farringdon*                    *www.smithfieldmarket.com*

## 25. Nos 33–35 Eastcheap, EC3

Nikolaus Pevsner, the architectural historian, described Nos 33–35 Eastcheap as 'a frenzy of sharp gables', which it certainly is. Designed by the architect Robert Louis Roumieu (1814–77) the building displays many fine Gothic features, clearly demonstrated in its spiky lancet windows, window hood moulds and pointed arched doorway. Ever since the building was opened in 1868 its design has set

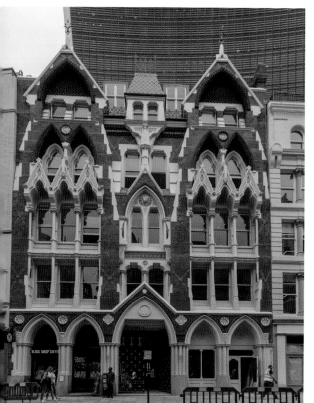

*Left*: Nos 33–35 Eastcheap.
(© A. McMurdo)

*Above*: Wild boar plaque on Nos 33–35 Eastcheap. (© A. McMurdo)

it apart from the adjoining buildings, and many consider that it has one of the Square Mile's most unique nineteenth-century commercial frontages. Nos 33–35 Eastcheap is certainly a striking building – the white stone windows contrast magnificently with the red and blue bricks and diaper work, and the façade is enhanced by beautifully carved mouldings, decorative motifs and tile frieze.

The building's original purpose was as a vinegar warehouse for Worcester-based company Hill, Evans & Co., but today is utilised as office and retail space. In the sixteenth century the site was occupied by the Boar's Head tavern, which Shakespeare mentions as the watering hole of Sir John Falstaff in his plays about Henry IV. Today, the tavern's name is immortalised in a carved medallion that sits above the central window. Look closely and you will see a boar crashing through undergrowth.

*Stations: Tower Hill, Monument*

## 26. Former St Paul's Choir School, Carter Lane, EC4

Opened in 1874, this eye-catching building was built as a school for the choir boys of St Paul's Cathedral, the school's first permanent home in over 200 years having lost its previous cathedral premises in the Great Fire. It owes its design to the eminent Victorian architect F. C. Penrose (1817–1903), who as a young man had travelled in France, Greece and Italy and was subsequently influenced by the style of buildings he had seen on his tours around the Continent. A glance at the school building immediately confirms Penrose's enthusiasm for classical architecture and this is well demonstrated in the school's Venetian and Renaissance features – the use of terracotta, round windows and doorways as well as its decorative panelling. What is especially unusual is the sgraffito frieze embellishing the school's façade that incorporates words in Latin and is written in Italian Renaissance script. The inscription begins 'MIHI AUTEM ABSIT GLORIARI...' (taken from St Paul's letter to the Galacians, 6:14) and is both a brilliant piece of craftsmanship and a stunning decoration. The technique of sgraffito dates to the Italian Renaissance and was used to beautify wall surfaces by scratching through the top surface to expose a lower layer in a contrasting colour. Although not a common form of ornamentation in the City of London, there are several examples of such work found on buildings in South Kensington that were designed around the same period.

St Paul's Choir School occupied the building until the 1960s when the threat of demolition due to a proposed road-widening scheme forced it to move to new premises – just around the corner in New Change. A decade later the former school was converted by the YHA Organisation into hostel accommodation catering for group and independent travellers. Since then, thousands of young visitors have stayed in this lovely old building, which is so very convenient for visiting the City's attractions, St Paul's Cathedral, the Tate Modern and Globe Theatre on the South

Former St Paul's Choir School. (© Sam McNeill)

Bank. Hostellers can still see some of the choirboys' graffiti in one of the former classrooms and enjoy the ambiance of this truly historic building.

*Stations: St Paul's, Blackfriars*                    *www.yha.org.uk*

## 27. Leadenhall Market, Gracechurch Street, EC3

Today Leadenhall Market has become a hugely popular tourist attraction as the market provided the setting in the movie *Harry Potter and the Philosopher's Stone* (2001) for the wizard's shopping street, Diagon Alley. This was where Harry, accompanied by Rubeus Hagrid (the keeper of keys and grounds at Hogwarts School of Witchcraft and Wizardry), purchased his first broomstick and a snowy owl after visiting Eeylops Owl Emporium. With its striking architecture and colourful interior, it is not surprising that the market has

been the backdrop for numerous movies, TV dramas and adverts as well as photographic shoots and pop videos.

Leadenhall Market is not only a location scout's delight but also a wonderful example of Victorian grandeur. Constructed in the late nineteenth century using cast iron and glass, it has a layout that is almost a series of attached streets located under a common glass roof and is easily accessed through any of its six entrances. It was designed by the City Architect Sir Horace Jones (1819–87), who is also known for his work on Billingsgate Market, Smithfield Market and Tower Bridge.

The market's interior is lined with shops, bars and restaurants and is richly painted in red, gold and cream. Colossal Corinthian cast-iron columns and a magnificent central lantern add to its splendour as well as decorations of dragons, coats of arms, carvings and mouldings. The famous Lamb Tavern, a favourite with many City workers, is a wonderful watering hole renowned for its food and ale and magnificent Victorian furnishings.

Exciting recent archaeological excavations have discovered that today's Leadenhall Market was a major trading site in Roman times, and that the present market actually sits above what was once the forum (marketplace) and Basilica (law courts) of Londinium. It was then the largest such site in Rome's Empire north of the Alps, and extended over an area greater than Trafalgar Square. From artefacts uncovered during investigations archaeologists have managed to gain a good picture of how the original buildings were constructed and how the market

Entrance to Leadenhall Market. (© A. McMurdo)

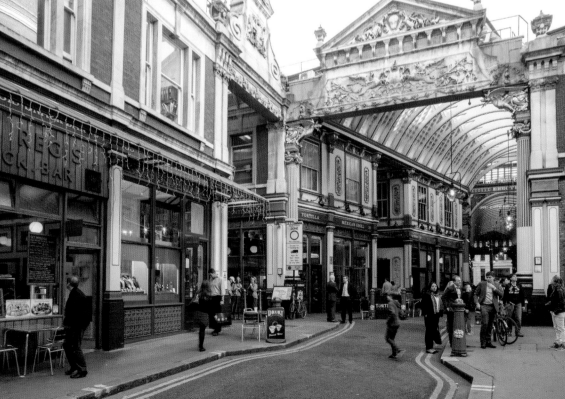

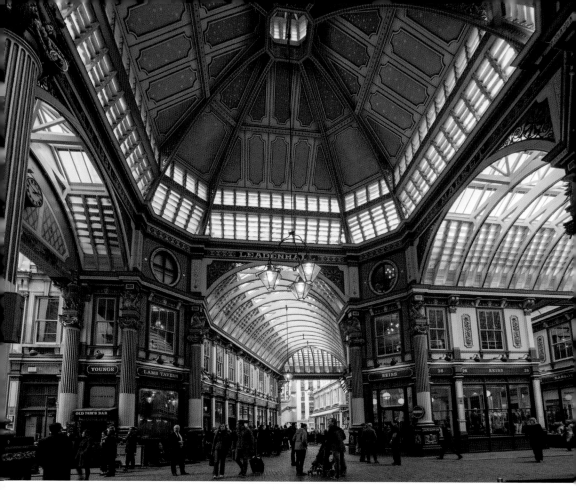

Grand lantern, Leadenhall Market. (© A. McMurdo)

would have looked. Many of these items, including a superb mosaic pavement, are now on display within the Museum of London (See No. 39, page 76).

*Stations: Bank, Monument*                    *www.leadenhallmarket.co.uk*

## 28. Royal Courts of Justice, Strand, WC2

Just outside the City's boundary and occupying a substantial plot of land at the eastern end of the Strand, the Royal Courts of Justice are a major landmark of the area. The building is easily identified by its white Portland stone exterior, red brick and ashlar along with its striking arcades, soaring towers, turrets, pointed arches, spires and stained-glass windows. It is a truly magnificent example of Victorian Gothic Revival architecture and is wholly due to the talent and hard work of its architect, George Edmund Street (1824–81). Street was a passionate advocate of ecclesiastical and Gothic design, which is why the Royal Courts of Justice building is sometimes mistaken as a church or cathedral rather than a

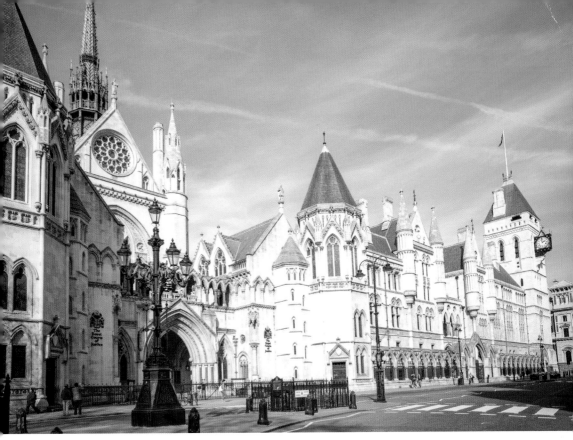

*Above and right*: Royal Courts of Justice. (© A. McMurdo)

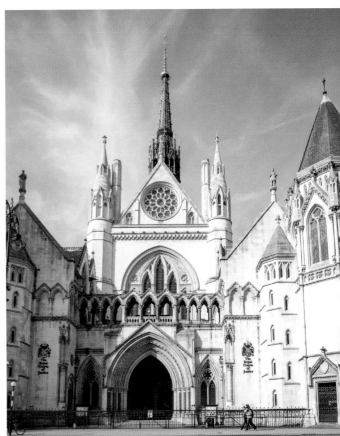

public building. Opened in 1882, the new court building was set up to house all of England's common law and equity courts (previously scattered across the capital), recognising the overhaul of the legal system between 1852 and 1873. The newly established courthouse immediately became the focal point of legal London and remains so today and is where the Court of Appeal for England and Wales and the High Court of Justice (incorporating its Queen's Bench, Chancery and Family divisions) sit. Visitors arriving through the main Strand entrance walk directly into the great hall, which is simply breath-taking on account of its size and height. Leading off the hall via decorated staircases are the building's many courtrooms, corridors, jury, waiting and interview rooms as well as offices, and many of these still retain their original furnishings.

The courts' work is hugely varied, ranging from custody and divorce arrangements to trials involving bankruptcy, libel suits and civil disputes. It is the place where high-profile cases are heard, such as the Duchess of Sussex's legal battle with the *Mail on Sunday*, and the libel trial between the actors Johnny Depp and Amber Heard.

Members of the public are free to visit the building on weekdays and are usually permitted to sit in the public gallery of any court to watch the trials taking place. It is possible too to join a tour of the building – places for this can be booked online.

*Station: Temple*                          *www.theroyalcourtsofjustice.com.*

## 29. The Old Bank of England Public House, No. 194 Fleet Street, EC4

Sitting adjacent to the Royal Courts of Justice is another stunning building that started life as the Law Courts' branch of the Bank of England. It opened in 1888 and continued as a financial institution for the best part of a century. In 1994, it was converted into an opulent Victorian-style public house and in memory of its former role named The Old Bank of England. Like its neighbour it is constructed in Portland stone, but that is where the similarities between the two buildings end as it is designed in a grand Italianate rather than Gothic style. With its tall, imposing corner pavilions, granite base and Doric, Ionic and red granite columns, it is certainly one of Fleet Street's most striking and prominent buildings.

The interior of the pub is even more splendid and is full of period features that include dark wood furnishings, floor tiles, wall paintings and murals, gigantic brass chandeliers and a highly decorated plaster ceiling. Although now one of several City banking halls to have been reinvented as a public house, it is undoubtedly the most impressive of them all and worth a visit as much for its food and drink as for its décor and ambiance.

*Station: Temple*                          *www.oldbankofengland.com*

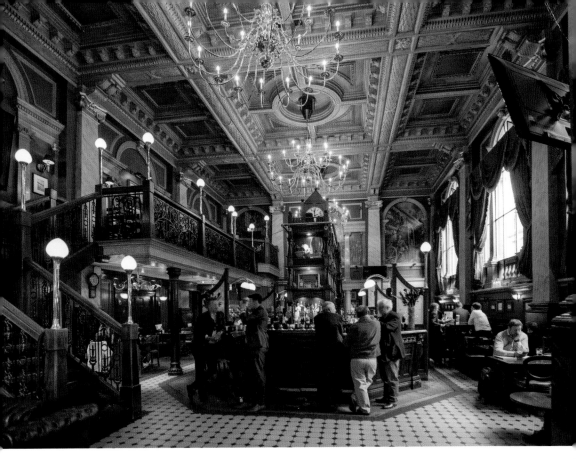

*Above*: Interior of The Old Bank of England public house. (© A. McMurdo)

*Right*: Exterior of The Old Bank of England public house. (© A. McMurdo)

## 30. Jamaica Wine House, St Michael's Alley, EC3

Tucked away in an ancient alleyway behind the church of St Michael Cornhill, the Jamaica Wine House is one of the City's most popular drinking venues. Despite its name it is a traditional pub that only opens Monday to Friday when office workers are in town. It is often so busy that the alleyway and surrounding backstreets are filled with crowds – tourists and City workers alike, who have spilled out from the pub.

Jamaica Wine House's present building was constructed in the late nineteenth century and designed in the art nouveau style. Only one storey high (though with a basement), with a prominent lamp bearing its name and built of red sandstone, it is hard to miss. Inside the floors and walls are covered in dark wood and the ground floor extends into several small, partitioned rooms. This area serves as the pub while the cellar below is run as Todd's Wine Bar as well as a restaurant.

On the wall outside is a plaque that reveals a bit more of the site's history explaining that in 1652 it was home to London's very first coffee house. It was set up by Pasqua Rosee, a man whose nationality is uncertain but was said to have come from either middle or southern Europe. Rosee had met London merchant David Edwards (who worked for the Levant Company trading in Turkish goods) in Izmir and was subsequently taken on as Edwards' manservant. When they returned to London Rosee, with Edwards' support, established the coffee shop,

Jamaica Wine House. (© A. McMurdo)

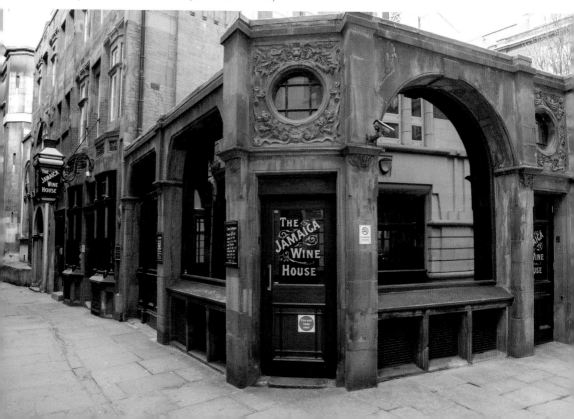

which became an immediate success. It was soon a major City hub frequented by merchants and intellectuals who discussed affairs of the day and networked with like-minded individuals. Rosee's success led to the setting up of many similar institutions around the City and each coffee house was associated with different areas of activity such as underwriting, marine and shipping interests. Although in time coffee houses lost their significance, it is interesting to see how in recent years the coffee house culture has returned to the City and is once more a place where meetings are held and business is carried out.

*Station: Bank*                                     *www.jamaicawinehouse.co.uk*

## 31. Tower Bridge, SE1

Tower Bridge, possibly one of the world's most recognised structures, actually sits just outside of the City's boundaries (although it is managed by the City of London). Nonetheless, it would be impossible to omit this unique bridge from the book as it is such a major landmark and recognised by so many people throughout the world. In 2012, when London hosted the Olympic Games over 900 million people watched the opening ceremony and followed David Beckham and the Olympic Torchbearer's boat journey along the Thames en route to the Olympic Stadium. As they approached Tower Bridge the bridge opened to the backdrop of a magnificent firework display – an event long to be remembered.

Tower Bridge with bascules opening. (© A. McMurdo)

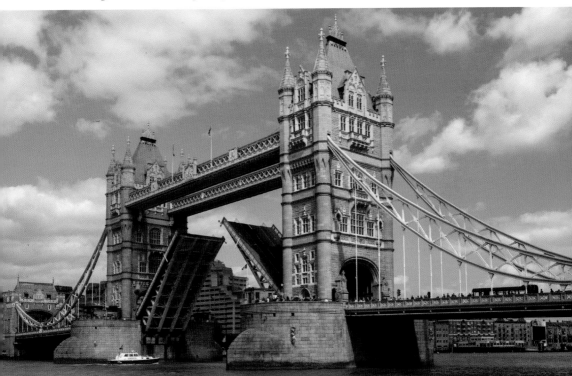

Although it appears much older, the bridge first opened in 1894. It owes its design to two men: the City Architect, Sir Horace Jones (1819–87), and the engineer Sir John Woolfe Barry (1836–1918). Horace Jones built Tower Bridge in the Gothic style to complement the nearby Tower of London and specifically designed it to have a section (a bascule) that could be raised and then lowered to allow the passage of tall boats along the river. Built of steel, the bridge has imposing twin towers rising from broad piers that support its two bascules and house their counterbalances. Up above, two high-level footbridges stretch between the towers and give amazing views east and west along the river.

Public entry to the bridge's interior is via the Tower Bridge Exhibition and the route through the attraction gives visitors access to the high-level walkways, one of which has a glass bottom floor. This not only provides excellent views of the road bridge and river below, but if you time your visit right, the opportunity to see the bascules opening. The exhibition ends in the Victorian engine rooms where the original steam-driven machinery is housed showing off the great engineering skill of its creators.

Naturally the bridge has featured in many movies, music videos and TV series but perhaps its most memorable and exciting scene was a car chase that took place across the opening bridge in the movie *Brannigan* (1975), which starred John Wayne in the title role.

*Stations: Tower Hill, London Bridge*          *www.towerbridge.org.uk*

View of Tower Bridge from the Tower of London. (© A. McMurdo)

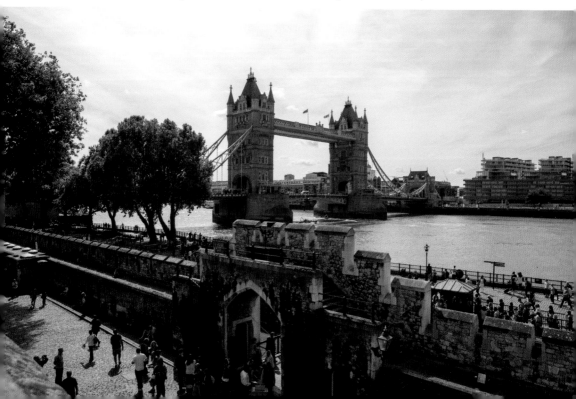

## 32. Memorial to Heroic Self-Sacrifice, Postman's Park, King Edward Street, EC1

This tiny enclave bordered by Aldersgate Street, King Edward Street and Little Britain sits beside St Botolph's, Aldersgate church. Surprisingly, many people pass by its gates daily in total ignorance of its existence or what it contains. Once a churchyard and burial ground it became a park in 1880 and soon after became known as 'Postman's Park' as it was where postmen from the nearby General Post Office headquarters came to relax in their work breaks. The post office moved out of their building many years ago, but the name has stuck and it remains a delightful green space amid the office buildings that surround it.

Postman's Park, apart from being a wonderful haven, is home to the Watts Memorial to Heroic Self-Sacrifice. This is a cloister with a 15-metre (50-foot) open gallery that displays ceramic tablets along its back wall recounting the stories of many ordinary people who lost their lives carrying out worthy deeds. The tablets, made up of a number of glazed tiles, were manufactured by the De Morgan and Doulton factories and some contain fitting decorations – a boat, flames or an anchor, signifying the situation that led to the act of heroism. There are tales of rescues from house and workplace fires, from canals and rivers, from broken ice and even quicksand. Sadly, fire and drowning are the predominant themes but there are also accounts of other courageous deeds such as that of

Memorial Loggia in Postman's Park. (© A. McMurdo)

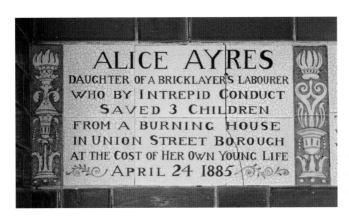

ALICE AYRES
DAUGHTER OF A BRICKLAYER'S LABOURER
WHO BY INTREPID CONDUCT
SAVED 3 CHILDREN
FROM A BURNING HOUSE
IN UNION STREET BOROUGH
AT THE COST OF HER OWN YOUNG LIFE
APRIL 24 1885

Wall plaque
commemorating
Alice Ayres.
(© A. McMurdo)

Frederick Alfred Croft. His tablet reads: 'Inspector, aged 51 who saved a lunatic woman from suicide at Woolwich Arsenal Station, but was himself run over by the train (January 11, 1878).' Another tells the story of pantomime artiste Sarah Smith, who lost her life on 24 January 1863 attempting to douse the flames that had enveloped her companion.

The wall, which officially opened in 1900, was the idea of the painter and sculptor G. F. Watts (1817–1904) as a memorial to commemorate the Diamond Jubilee of Queen Victoria in 1897. Today there are fifty-four memorial plaques, the last one having been added in 2007 to remember Leigh Pitt, who died saving a drowning child from the canal.

*Stations: St Paul's, Barbican, Farringdon*                *www.wattsgallery.org.uk*

## 33. The Old Bailey, EC4

London's Central Criminal Court, the Old Bailey, is built on the site of the former Newgate Prison – an institution known to be the most brutal of penal institutions and much feared by the residents of London for hundreds of years. The prison not only had a reputation for its harsh conditions but was also renowned for its overcrowding and as a place where disease was rife. After a life of more than 700 years the gaol closed in 1902 and was replaced by the present Central Criminal Court, designed by the architect E. W. Mountford (1855–1908), who was known mainly for designing town halls, often in the Edwardian baroque style. The court, standing at the junction of Old Bailey and Newgate Street is an imposing building and covers a large plot of land (having been extended to include a suite of new courts in the early 1970s). Its elegant, copper-roofed dome, surmounted by the figure of Justice holding the sword of retribution and scales of justice, stands out on the skyline and can be seen for miles around. The interior too is quite splendid. Dominated by the central staircase of stone, alabaster and marble and a most striking dome the main entrance hall is further filled with mosaics, marble, intricate carvings, sculptures and allegorical paintings.

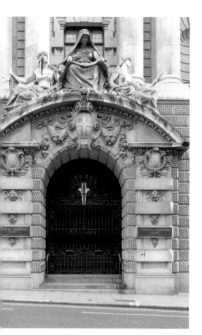
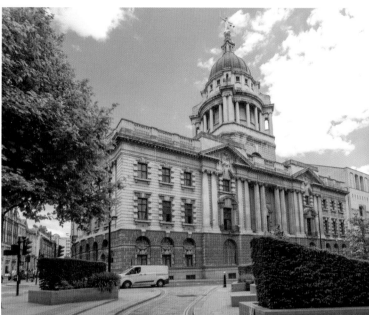

*Above left*: Old entrance to the Old Bailey. (© A. McMurdo)

*Above right*: The Old Bailey. (© A. McMurdo)

Courts 1 and 2 in the original building are probably the most famous of the Old Bailey's eighteen courts and are where most high-profile cases have been tried. Court 1 is where key criminal cases from the Greater London area are heard and cover such felonies as treason, theft, murder, fraud, rape and arson. High-security cases generally take place in Court 2. Many famous trials have been heard in these courts including those of Oscar Wilde, Dr Crippen, Lord Haw-Haw (William Joyce), the Kray twins, Peter Sutcliffe and Ian Huntley. Members of the public are free to attend a trial but be aware that the Old Bailey has strict rules banning mobile phones, cameras, writing equipment, food, drink, backpacks and penknives anywhere in the building and there are no lockers provided to leave these items on the premises.

*Stations: St Paul's, Farringdon*           *www.cityoflondon.gov.uk*

## 34. Nos 120 and 135 Fleet Street, EC4 (Daily Telegraph and Daily Express Buildings)

As mentioned previously (No. 13, page 32) Fleet Street was the major home of the printing and publishing industries from the early 1500s. It was the place where the printed word in all its forms (in books, plays, political pamphlets, legal documents, journals, magazines and newspapers) was published until the industry moved

away from the street in the 1980s. Walk along Fleet Street today and you can still see reminders of its newspaper and news industry's past in signs decorating the fronts and sides of buildings such as D. C. Thomson's 'Sunday Post' building at No. 186 and the London News Agency at Nos 44–46.

For most of the twentieth century Fleet Street was buzzing with activity, especially during the evening when journalists produced their copy and printers were preparing the next print run. There was constant bustle and at night the street was full of vans and trucks waiting to load the newspapers for distribution. At this time all the major newspapers had a presence in Fleet Street, some with editorial offices only while others had printing presses too. Nos 135–41, a wonderful Egyptian-looking building characterised by its six giant fluted columns and a highly coloured ornamental clock, was built for the Daily Telegraph in 1928 and housed the newspaper's machinery and offices over six floors. I remember a visit to the building as a teenager and being overawed by the size of the printing presses and the deafening noise they made. This was shortly before computers were introduced that ultimately changed both the face of the industry and Fleet Street forever.

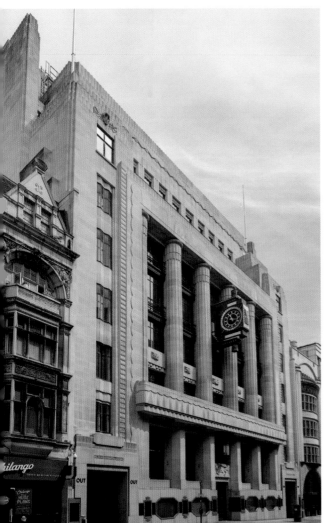

*Left*: Former Daily Telegraph building. (© A. McMurdo)

*Below*: Clock on the former Daily Telegraph building. (© A. McMurdo)

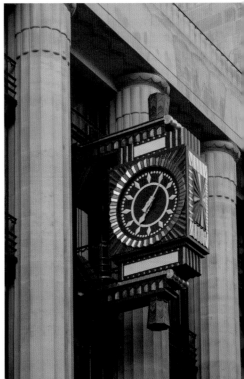

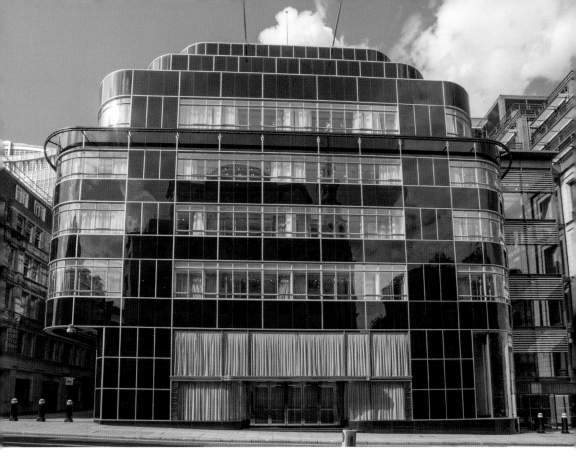

Former Daily Express building. (© A. McMurdo)

Further down the street at No. 120 is the site of the former head office of the *Daily Express* newspaper. Impossible to miss due to its shiny black Vitrolite and glass curtain-walled art deco exterior, the modernist building was designed for its proprietor, Lord Beaverbrook, and contains a spectacular entrance lobby with an enormous, silvered ceiling pendant and magnificent staircase. For years the lobby has been inaccessible to the public, but with the recent departure of its tenants, Goldman Sachs, the City of London plan to turn it into a 'publicly accessible cultural destination'.

*Stations: Blackfriars, City Thameslink*

## 35. Ibex House, Nos 42–47 Minories, EC3

Ibex House opened as a speculative office development in the mid-1930s when the art deco movement was at its height. It was built in the streamline moderne style of modernist architecture, a design then prevalent with London's Odeon cinemas. The office block, eleven storeys high (plus a basement) is built around a structural steel frame and arranged in a 'H' shape. The substantial building occupies an island site of 0.75 acres, and it is bounded by Mansell, Portsoken and Haydon Streets on its east, south and north sides and has its main entrance on the Minories.

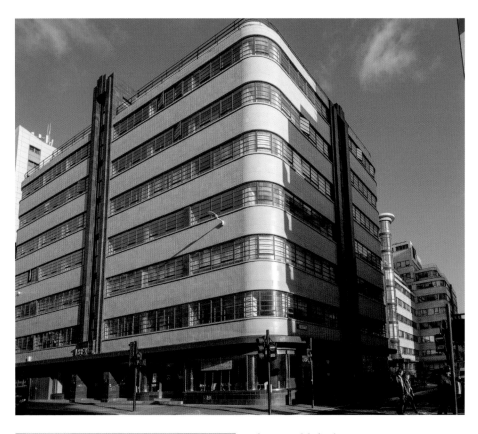

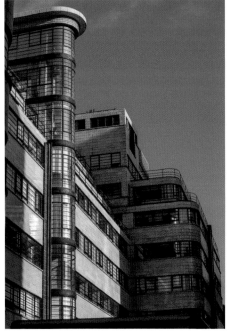

*Above and left*: Ibex House.
(© A. McMurdo)

Designed by the architectural practice Fuller, Hall and Foulsham Ibex House displays a mixture of horizontal bands of faience cladding, black for the lower levels and buff faience above. It has some wonderful architectural features too seen in its curved corners, central glazed staircase towers and black metal framework. The architectural historian Nikolaus Pevsner commented on its 'long bands of glass, whizzing round curved corners', and when it was erected in 1937 the building was said to possess the longest bands of glass in the UK. Ibex House is an excellent example of the fairly short-lived streamline moderne style and unique in this part of the City today.

*Stations: Tower Gateway, Tower Hill, Aldgate*

## 36. Bracken House, No. 1 Friday Street, EC4

Bracken House, built in 1958 as the home for the *Financial Times* (FT) newspaper, is immediately recognisable on Cannon Street due to its highly unusual astronomical clock that sits above the main doorway. Brightly coloured in cobalt blue and decorated with the signs of the zodiac, the clock displays a face of a well-known personality in its centre. It is of the statesman and former prime minister Sir Winston Churchill (1874–1965), who was both a good friend as well as mentor to the founder of the newspaper, Brendan Bracken (1901–58). The two men worked closely together from 1923, Bracken always supporting Churchill in his political endeavours and later taking on the position of Minister of Information in Churchill's wartime government. After the war Bracken returned to publishing and

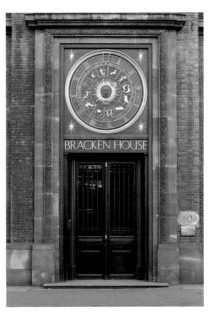

Astronomical clock on Bracken House.
(© A. McMurdo)

Bracken House. (© A. McMurdo)

merged the *Financial News* with the *Financial Times* turning it into the country's most successful business paper. Sir Albert Richardson (1880–1964), the eminent architect and proponent of modern classicism designed Bracken House for the *Financial Times*' printing works and editorial offices. He faced the exterior walls in red brick and pink sandstone, thereby emulating the colour of the newspaper.

In the late 1980s, the *Financial Times* moved away from the City and the building was taken over by the Obayashi Corporation, who commissioned the contemporary architect Michael Hopkins (b. 1935) to redesign Bracken House. Instead of printing presses the specification now was for financial trading floors and office space, and Hopkins devised plans to accommodate this by demolishing much of the original building. This met with such resistance that Bracken House was awarded listed status and ultimately only the printing press hall was pulled down. Hopkins' design unlike that of his predecessor was largely metal and glass in keeping with his high-tech style of architecture. Like the earlier Financial Times building, it later acquired listed status.

Most recently Bracken House has been refurbished and is once again occupied by the *Financial Times*. John Robertson Architects (JRA) have given it many new features including a roof garden, terrace and running track. They have also introduced two internal courtyards giving the building more fluidity and allowing for much better access between the central block and the building's two wings.

*Stations: St Paul's, Mansion House*

## 37. London Bridge and St Magnus the Martyr Church, EC3

The first London Bridge spanning the Thames was built by the Romans in or around AD 50 and remained the only place to cross the Thames until the mid-eighteenth century. This bridge, like other later timber replacements, did not have a long life but a stone bridge erected in 1209 remained in situ for the next 600 years. Designed by the cleric Peter de Colechurch (1150–1205) it was made up of nineteen narrow and irregular arches and was lined with buildings of every sort – from houses, market stalls and shops to chapels, gatehouses and even a palace! The gatehouses at either end of the bridge could however be a sombre sight as they exhibited the heads of traitors and criminals as a warning to prevent others from carrying out heinous acts. Unfortunately, the bridge's wide pier bases along with its slim arches caused major disruption to the river's water flow. This made it difficult for boats to navigate the medieval bridge and in winter caused the river upstream to freeze. The situation eased in the 1830s when a new bridge with five arches replaced the medieval crossing. Designed by the famous Scottish civil engineer John Rennie (1761–1821), it remained in use until the late 1960s when a new wider bridge was built to cope with the increase in road traffic. Interestingly,

*Above*: London Bridge.
(© A. McMurdo)

*Right*: St Magnus
the Martyr Church.
(© A. McMurdo)

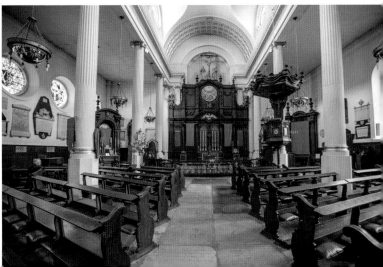

Model of
the medieval
London Bridge
in St Magnus the
Martyr Church.
(© A. McMurdo)

Rennie's bridge was bought by an American developer who then had it transported, stone by stone, to Lake Havasu City, Arizona, where it stands today.

A super model of the medieval bridge is exhibited within St Magnus the Martyr Church located at the northern end of the bridge in Lower Thames Street. It is a fitting place for its display as the church has served the parishioners of the area since the twelfth century. Today's church was constructed post-1666, the work of Sir Christopher Wren and his craftsmen. Its striking exterior tower and octagonal lantern together with its wonderful interior flooded in white and gold make it well worth a visit. It is particularly noted for its fluted Ionic columns, exceptional woodwork, its neo-baroque reredos and magnificent west gallery.

*Stations: Monument, London Bridge*          *www.stmagnusmartyr.org.uk*

## 38. The Barbican Arts Centre and Estate, EC2

The Barbican Estate, with its soaring triangular towers and reinforced concrete structures, has been a source of great controversy and debate since its construction between 1962 and 1982. It fills an area of just 40 acres and was built on land almost entirely flattened by enemy bombing during the Second World War. After the war, in the hope of bringing back vitality and life to the City, the Corporation of London envisioned a state-of-the-art development on the bombed-out site that would provide new housing, schools, shops, open spaces and an arts complex. It was to become a city within the City regenerating the devastated area – a phoenix arising from the ashes.

The construction of the Barbican's three tower blocks began in the early 1960s and with their height, angular shape and unpainted raw concrete they looked quite unlike any structures previously erected in the City. Devoid of the more familiar classic architectural features, the revolutionary brutalist style employed by the

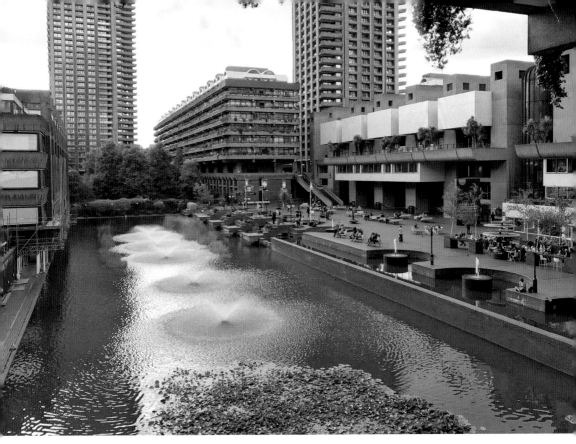

*Above and below*: The Barbican Estate. (© Ben McMurdo)

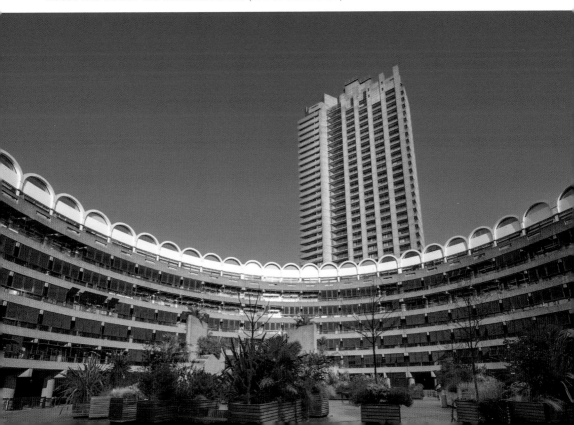

architects Chamberlin, Powell and Bon was considered by some to be severe, even soulless. Yet others appreciated the new futuristic design and felt it represented post-war London.

Due to the site's lack of space many of the estate's buildings were raised on podia, and high-level walkways were introduced to separate the traffic beneath from pedestrians above. The walkways proved highly successful and had the added advantage of providing excellent views of the estate's landscaped gardens that incorporated part of the Roman wall, the City of London Girls' School, the medieval church of St Giles Cripplegate as well as a large lake with fountains. Not until 1971 did work begin on the construction of the Barbican Arts Centre that was to provide theatres, cinemas, an art gallery, a library, concert hall, conservatory as well as exhibition halls. Taking just over a decade to complete the centre was designed to appear spacious – extending across seven levels with grand foyers, a basement and mezzanine floors.

Now, forty years on, the corporation as part of its plans to remake the City into a wider cultural destination has approved a revamp of the centre so that it continues to meet changing modern demands.

*Stations: Barbican, Farringdon, Moorgate*                    *www.barbican.org.uk*
                                                               *www.cityoflondon.gov.uk*

### 39. The Museum of London, No. 150 London Wall, EC2

Run by the City of London Corporation, the Museum of London moved into a purpose-built Modernist site on London Wall in 1976 where it remained until December 2022. Its home, right next to the Barbican arts complex was always a source of contention as it was not easy to see from the street, built high above road level on a walkway that connected it with the Barbican, and at first visitors had difficulty finding the entrance. However, as the museum became known it was deemed to be 'the' place to find out about London's history and social background. Its early collections, which emanated from the Guildhall Museum and London Museum, consisted of half a million objects but over the decades the museum's collection has grown to such a great extent that its core collection has now doubled and includes an extra six million 'finds' (small pieces discovered during archaeological excavation). With 50,000 objects from the prehistoric period and Roman London, and an enormous collection of items from Saxon and medieval times to the present day, it has become increasingly difficult to display the museum's entire collection. Nonetheless, visitors have delighted in the many treasures on display, learning about the Great Fire of London 1666, experiencing life in a Georgian Pleasure Garden and seeing the 2012 London Olympic Games Cauldron up close.

The need for larger premises comes at a time when the Corporation of London has created the City Culture Mile and is promoting the City of London as a major

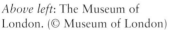

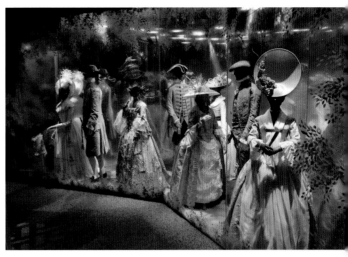

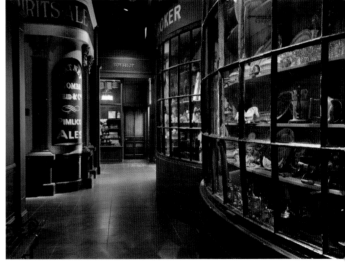

*Above left*: The Museum of London. (© Museum of London)

*Above right*: The Georgian Pleasure Garden in the Museum of London. (© Museum of London)

*Right*: The Victorian Walk in the Museum of London. (© Museum of London)

cultural destination. For this reason it has supported the Museum of London's move into what were once the General and Poultry (Grade II listed) buildings of Smithfield Market, a site that has been mainly derelict for some years. The architects, Stanton Williams and Asif Khan aim to provide much needed additional exhibition space in wonderful and atmospheric historic settings to showcase the museum's collections. Objects from a 10,000-year period will be displayed here chronicling London's rich and vibrant history; jewellery, clothing, textiles and artworks will be exhibited alongside Roman mosaics, pre-historic animal skulls and even modern fatbergs. When it reopens in 2026 the museum will be rebranded as the London Museum.

*Stations: St Paul's, Barbican, Farringdon*                    *www.museumoflondon.org.uk*

## 40. Lloyd's of London, No. 1 Lime Street, EC3

Dating back to the mid-1600s, Lloyd's began life in Edward Lloyd's Coffee House at a time when coffee houses were all the rage. Lloyd's Coffee House attracted anyone with an interest in the shipping industry and soon became the place to pick up the latest shipping news and ultimately to obtain marine insurance. In time its portfolio expanded to include many other areas of insurance covering technology, space and sport as well as insuring an opera singer's vocal chords, dancers' and footballers' legs and even a musician's hands.

Lloyd's opened its first headquarters in Leadenhall Street in the late 1920s, but replaced it in 1986 with the present building designed by the celebrated twentieth-century architect Richard Rogers (1933–2021). At the time there were no other high-rise buildings in the vicinity apart from the NatWest Tower (later renamed Tower 42), nor was there anything remotely similar in design to Rogers' extremely modern high-tech building. Constructed in steel, concrete and glass and with its inside-out aesthetic it was without doubt the most novel of structures to be placed in the traditionally conservative Square Mile. Not surprisingly it was controversial

*Below left and below right*: Lloyd's of London. (© A. McMurdo)

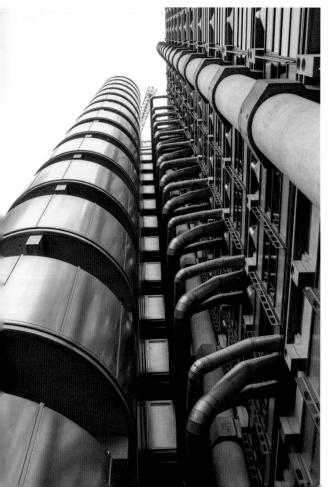
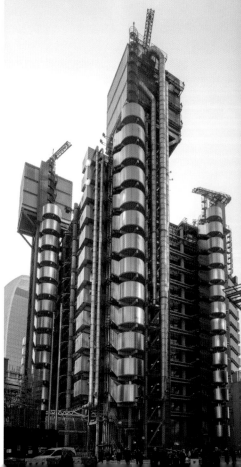

and considered by many to be truly revolutionary. Even today it looks futuristic and stands out amongst its neighbours with its exterior pipework, ducts, lift shafts, air-conditioning plant and power supplies. The interior too is quite stunning; by placing all the main service and maintenance equipment externally, Rogers created uninterrupted interior spaces enabling him to build a 60-metre-high atrium that is home to Lloyd's magnificent Underwriting Hall.

When Rogers accepted the commission from Lloyd's it was with the understanding that the building should be equipped to serve it well into the twenty-first century and one that would be fitting for a global giant of the specialist insurance market. Rogers delivered this through the in-built flexibility of his design, which together with the building's innovative style resulted in it being awarded Grade I listed building status in 2011.

The building is still iconic and an exceptional example of high-tech architecture, remaining as awe-inspiring today as when it was first built.

*Stations: Bank, Liverpool Street, Monument*                    *www.lloyds.com*

## 41. Broadgate Estate, EC2

The Broadgate Estate is built alongside Liverpool Street station on land that was originally home to Broad Street station. Opened in 1865, the station was the terminus for the North London Railway (NLR) and the railway was initially successful in providing a popular commuter and freight service between East and West London. Over the years, however, it found itself unable to compete with other transport services, its passenger numbers declined and its freight provision ceased. The station finally closed in 1986, after which approval was granted for the railway and its goods yards to be demolished. The site's new owners, British Land, then began to transform the site into a large commercial centre with a mix of office and retail accommodation and public spaces. Covering a site of 32 acres, the initial phase was largely designed by two architectural practices, Arup Associates and Skidmore, Owings and Merrill (SOM), and resulted in some exciting and innovative architecture such as Broadgate Arena and Exchange House. The latter, built in Exchange Square, has the appearance of a huge bridge over Liverpool Street station's railway tracks below. Since it was built in 1990 this square, like the estate's other open spaces, has frequently been used as a setting for movies, commercials and TV programmes. All around the estate you can see wonderful modern artworks and installations, the work of well-known international and British artists and there is a map of the Broadgate Art Trail available on www.broadgate.co.uk.

The Broadgate Estate has been one of the City's most successful recent developments with interesting architecture and a diverse range of restaurants, shops, bars and gyms. It also had its own Italian food market and a boutique cinema. With companies such as UBS, AXA and McCann based here it has an

*Above*: Entrance to No. 100 Liverpool Street, Broadgate Estate. (© A. McMurdo)

*Left*: Eataly at No. 135 Bishopsgate, Broadgate Estate. (© A. McMurdo)

equally impressive tenant portfolio. Constantly upgrading its buildings and facilities, Broadgate is in an excellent location, close to the financial hub of the City and technical and media centres based around Shoreditch and Old Street and, furthermore, is extremely well connected to the Tube and rail network. It is a thriving hub filled with people all through the day and night.

*Stations: Liverpool Street, Moorgate*                    *www.broadgate.co.uk*

42. Minster Court, Mincing Lane, EC3

Mincing Lane runs between Fenchurch Street and Great Tower Street and today is very much the heart of the City's insurance district. Historically, it was home to the tea and spice trades and during the nineteenth century at a time when tea auctions were held in the street many tea merchants had offices here, which gave rise to it being labelled as the 'Street of Tea'.

Minster Court is a simply extraordinary edifice and is strikingly different from any other building within the City. Designed by GMW Partnership it was constructed between 1987 and 1991 and consists of three enormous blocks of offices that are connected by glass roofs. It is an eccentric postmodernist building that, with its sharp gables and roofs, has a Kafkaesque quality and bears similarity to many a castle or cathedral. Whether you like it or not (it has been referred to as both surreal and hideous) it is a unique structure and has a definite presence due to its rose-coloured granite and marble exterior. A particularly interesting artwork consisting of three large bronze horses sits on the building's forecourt, the work of Althea Wynne. Nicknamed 'Dollar', 'Yen' and 'Sterling', they are purported to represent the world's chief financial trading centres – New York, Tokyo and London. The site

Minster Court from Plantation Lane. (© A. McMurdo)

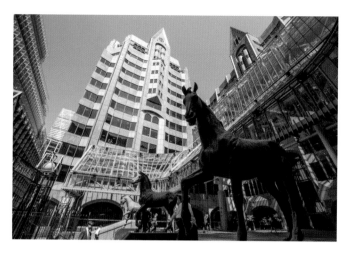

Minster Court.
(© A. McMurdo)

may seem familiar to anyone who has seen the movie *101 Dalmations* (1996) as it was the setting for 'the House of deVil', Cruella de Vil's fashion house.

Mincing Lane is also where in the late 1990s archaeologists exposed the remains of a first-century Roman fort and discovered a wonderful hoard of forty-three 22-carat gold coins. The coins, dating to AD 173–74, were found in mint condition and are now displayed in the Museum of London. Nearby this area is a new pedestrian route that was created in 2000 alongside the Plantation House development. It not only follows the pattern of the City's ancient medieval alleys but has many references to London's long and fascinating history written in text on the ground. It forms part of a piece of public art called *Time and Tide* and is the work of the British artist Simon Patterson.

*Stations: Tower Hill, Monument*

## 43. No. 1 Poultry, EC2

No. 1 Poultry is located on a prime site at Bank junction and is part of a group of the City's most historic and significant buildings. It is a dominant and monumental structure that straddles Poultry and Queen Victoria Street and is unmissable both for its bulk and colour. One's first impression of its colour is of a salmon-pink and creamy-yellow (in fact, buff and red sandstone) and the colours are picked out in alternating bands. The building as it faces Bank Junction is characterised by its conspicuous cylindrical tower, angled window and prominent clock. Claims have been made that it resembles a ship's prow although King Charles III once described it as looking like a '1930s wireless set'.

The building itself contains shops, offices, a restaurant, and roof garden and is accessed via two entrances. Above the Poultry entrance is an interesting terracotta frieze that once hung on a previous building here. It is the work of the nineteenth-

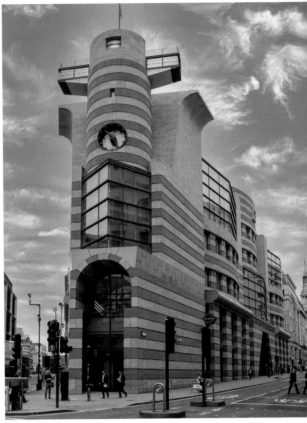

*Above*: Frieze above the entrance to
No. 1 Poultry. (© A. McMurdo)

*Right*: No. 1 Poultry. (© A. McMurdo)

century German artist Joseph Kremer (1833–82) and depicts a series of four royal processions (progresses) that are believed to have passed by the site. A plaque within the entrance explains that 'Panel A depicts King Edward VI, Panel B Queen Elizabeth I, Panel C King Charles II and Panel D Queen Victoria'.

The building was designed by the renowned twentieth-century architect James Stirling (1926–92) – after whom the annual architectural Stirling Prize is named. He was commissioned by the property developer Lord Palumbo to redevelop the site replacing a group of Victorian buildings that included the listed Mappin and Webb building. The opposition to Stirling's proposed postmodernist design was enormous and by the time planning permission was finally granted Stirling had passed away and the work was subsequently carried out by his partner Michael Wilford. Even after twenty years No. 1 Poultry's construction remains controversial. Nonetheless, in 2016 Historic England awarded the building Grade II* listed status for its 'very high architectural merits', its place within Bank Junction and as the work of eminent post-war architect James Stirling. It is considered to be an 'unsurpassed example of commercial post-modernism'.

*Station: Bank*

## 44. Millennium Bridge

When the Millennium Bridge opened in June 2000 it was the first new crossing to span the Thames for 100 years and also the first pedestrian-only bridge to be erected in London. It was built as a suspension bridge and owes its design to the architects Foster and Partners, the engineering company Arup and sculptor Sir Anthony Caro. In accordance with their brief from Southwark Council the designers drew up plans for a bridge that was fitting for the new millennium and one that would not obscure the view of St Paul's Cathedral on the North Bank. To meet these criteria, they elected to build not a conventional suspension bridge but

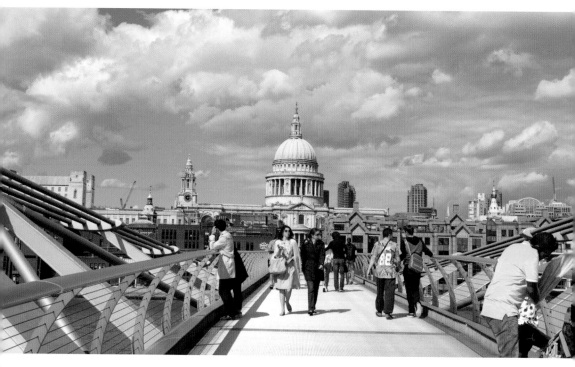

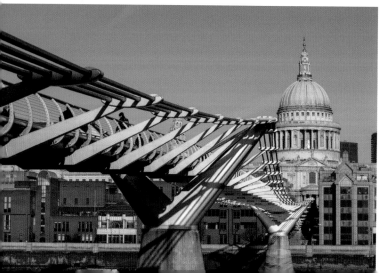

*Above and left*:
Millennium Bridge.
(© A. McMurdo)

one that was flattened with cables running low down beside the deck rather than above the structure, and Y-shaped piers were embedded in the river at intervals along its length to provide it with support.

Although the bridge initially suffered from a slight sway, giving rise to its name of 'the Wobbly Bridge', this was soon rectified and it has since become one of London's most loved landmarks. It is used by millions of people each year as they move between the City and the South Bank.

*Stations: St Paul's, Mansion House, Blackfriars*

## 45. Nos 30 and 70 St Mary Axe, EC3

Built on the site of the former Baltic Exchange that was severely damaged by an IRA bomb in 1992, No. 30 St Mary Axe opened for business in 2004 and instantly became an icon in the City's EC3 district on account of its distinct shape, its external glazing and diagonal bracing. Designed by Foster + Partners as head office for the reinsurance company Swiss Re, it is said to be London's first ecologically constructed building. Not only designed to optimise the use of daylight and natural ventilation it also uses far less energy than contemporary structures. The architects brought an entirely new form of architecture into the Square Mile that received immediate acclaim and resulted in the practice being awarded the 2004 Sterling Prize, in recognition of the building's novel technical and environmental design. From the outset the building was dubbed 'the Gherkin', a name that it is known by globally today.

The Gherkin is forty-one storeys high, expanding in size as it rises and then tapering towards its summit. It is 189 metres tall (591 feet) and floors 38–41 are dedicated to wining and dining. At the very top, sitting under the building's curved, lens-shaped cap (the only curved piece of glass in the entire building!) is a public bar with spectacular views of the city. The setting is quite wonderful and has become a popular venue for wedding celebrations, launches, social events and private dining.

There are retail outlets and restaurants at the base of the Gherkin, and it is surrounded by a large public plaza that frequently houses art installations on the City's Sculpture Trail. The building has appeared in many movies including *Transformers: The Lost Knight* (2017), *Red 2* (2013), *Basic Instinct 2* (2006) and *Match Point* (2005).

No. 70 St Mary Axe nearby is another attractive and unusual building that was completed in 2019. With only twenty-three floors it is considerably smaller than the Gherkin yet is highly individual with its arched form of two curved façades. Designed by the architectural practice Foggo Associates it has acquired the name the 'Can of Ham' due to its unique shape.

*Stations: Aldgate, Bank*                    *www.searcysatthegherkin.co.uk*

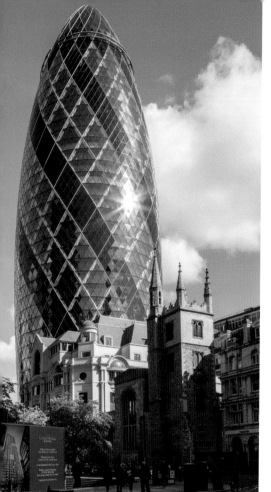

*Above*: No. 70 St Mary Axe (the Can of Ham).
(© A. McMurdo)

*Left*: No. 30 St Mary Axe (the Gherkin).
(© A. McMurdo)

## 46. East City Cluster: In and Around Leadenhall Street, Bishopsgate and Lime Street

Since the late twentieth century the eastern corner of the City has been defined by its number and variety of tall office towers. Most of the buildings are sited in and around Leadenhall Street, Bishopsgate and Lime Street and range from as little as fifteen to more than sixty storeys high. Several, like the Walkie Talkie, Cheesegrater and Scalpel, have been given nicknames due to their design while others, like Lloyd's are known by the name of the building's occupier. Tower 42 (formerly the NatWest Tower) was the City's first skyscraper, built in the 1970s. At 183 metres (600 feet) high it remained the tallest building in the City until 2011. Over the past fifty years the City's skyline has been revolutionised by avant-garde structures, designs of extremely talented architects of British and global repute. In particular, this area of the City showcases the work of two prominent British architectural firms, Rogers Stirk Harbour & Partners and Foster + Partners. The

*Above left*: Tower 42. (© A. McMurdo)

*Above right*: No. 22 Bishopsgate and the Leadenhall Building (the Cheesegrater). (© A. McMurdo)

Rogers Partnership's buildings include the Cheesegrater at No. 122 Leadenhall Street and Lloyd's Building at No. 1 Lime Street, while Foster + Partners designed the Gherkin at No. 30 St Mary Axe and the Willis Building at No. 51 Lime Street. Many other architectural practices such as Kohn Pederson Fox, Foggo Associates, PLP Architecture and Cesar Pelli and Associates have also contributed to the diversity of buildings here; there are wonderful examples of the high-tech, postmodern and future modern styles, some displaying extraordinary design and using new forms, often testing the boundaries of what can be built. Many towers have received architectural and environmental accolades and the trend is for 'green' features such as roof gardens and walls, buildings that are awash with natural light and ventilation and are equipped to generate renewable energy.

From the graceful, stepped design of the Willis Building to the sharp angular look of the Scalpel there is something that appeals to everyone who works or visits the City. Perhaps a hint of things to come is No. 22 Bishopsgate, a lofty

The Scalpel highlighted by the setting sun on the city skyline. (© A. McMurdo)

sixty-two-storey tower that is designed 'to make work sociable and pleasurable' with its art features, gym, holistic centre and basement bike park.

*Stations: Aldgate, Monument, Bank*

## 47. One New Change, EC4

In medieval times Cheapside was the City's chief shopping district, much as London's Oxford Street is today. Just wander along the street and you will come across names like Milk Street and Honey Lane, signifying the type of goods once sold here.

One New Change opened in 2010 as the first dedicated shopping mall in the City and was designed by the much-acclaimed French architect Jean Nouvel (b. 1945). It is sited close to St Paul's Cathedral and easily recognised because of its multicoloured glass exterior that is made up of clear and opaque panels that change the appearance of the building at different times of the day. The centre is filled with shops and restaurants and opens daily.

Nouvel's design of the building has cleverly managed to connect it to its surroundings and visitors are treated to magnificent views of the cathedral dome inside the centre's glass elevators. Take a trip to the rooftop for a meal or cocktail at Madison's Restaurant and Bar and enjoy wonderful panoramic views over the River Thames and the Square Mile from the roof's public viewing terrace. The terrace becomes the venue for many screenings such as the Wimbledon tennis championships during summertime.

*Station: St Paul's*  *www.onenewchange.com*

*Above*: One New Change.
(© A. McMurdo)

*Right*: The rooftop at One New
Change. (© Ben McMurdo)

48. No. 20 Fenchurch Street, EC3

Designed by the Uruguayan New York-based architect Rafael Vinoly (b. 1944),
No. 20 Fenchurch Street rapidly became known as 'the Walkie Talkie' on account
of its distinctive concave form. Completed in 2014, it is a uniquely shaped tower
that has its greatest floorplate at the summit, making it appear both bulky and at
times somewhat top heavy. While under construction the building experienced a
solar glare problem, resulting in damage to cars parked on the street. The reflected
heat was so intense that it even enabled a City journalist to fry an egg in a pan at
ground level. Steps were taken immediately to remedy the fault resulting in the

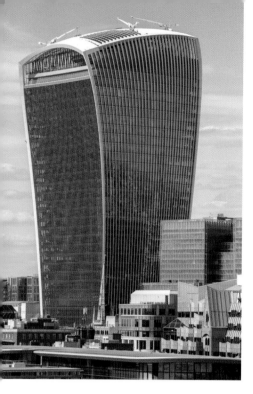

*Above*: The Sky Garden at No. 20 Fenchurch Street. (© Rhubarb)

*Left*: No. 20 Fenchurch Street (the Walkie Talkie). (© A. McMurdo)

fitting of a brise-soleil sunshade over the glass windows and this remains part of the building's structure today.

The Walkie Talkie is thirty-eight storeys high and has a free public viewing gallery at its summit along with a small park (the Sky Garden), two restaurants and a bar. The viewing gallery opens every day, but it is essential to book a time slot for entry. Visitors are treated to wonderful 360-degree views of London here through the vast floor-to-ceiling windows and there is also a breezy outdoor terrace looking south across London.

*Stations: Monument, Bank*                              *www.skygarden.london*

## 49. The Bloomberg Building and the London Mithraeum, Queen Victoria Street, EC4

Bloomberg London was designed as Bloomberg's European headquarters and is the brainchild of Michael Bloomberg working hand in hand with Sir Norman Foster (b. 1935). At ten storeys high the building sits well in its urban environment and great care has been taken to protect the view of St Paul's Cathedral nearby. The building extends over 3.2 acres and is nestled between Queen Victoria Street, Cannon Street and Walbrook. Clad in Derbyshire sandstone, it is easily identified by its bulky bronze window fins that give shade to the building. Foster + Partners designed the headquarters as two buildings linked by bridges that

*Above*: The Bloomberg building. (© A. McMurdo)

*Below left*: *Forgotten Streams* in front of the Bloomberg building. (© A. McMurdo)

*Below right*: The entrance to the London Mithraeum, Walbrook. (© A. McMurdo)

cross over a newly installed pedestrian way, the Bloomberg Arcade. Today, the arcade, lined with restaurants and cafés, is a busy thoroughfare – a reminder perhaps of how it would have been when Watling Street, the Roman road, passed through here. The building's exterior is particularly enhanced by the creation of three new public plazas as well as stunning water sculptures found at either end of the Bloomberg Arcade. Entitled *Forgotten Streams*, they are the

work of the Spanish installation artist Cristina Iglesias and commemorate the (now subterranean) River Walbrook.

In Roman times the Walbrook was a major trading centre, so it is hardly surprising that excavations of the area have unearthed a wealth of Roman artefacts. A major find in 1954 was of the Roman Temple of Mithras. Reassembled, it fronted an office block in Queen Victoria Street until 2010 when Bloomberg purchased the site. His pledge to restore the temple at the site of its original discovery within his building has resulted in the creation of an interpretation centre, the London Mithraeum. Here in the building's basement visitors are treated to an exciting and immersive experience of the Temple of Mithras.

On the ground floor fascinating objects discovered during pre-construction excavations that give a glimpse of life in Roman London are on display. All manner of everyday things from hairpins to tools, metalwork and jewellery were found, but perhaps the most significant of all was a collection of writing tablets, including one dated AD 57 – the City of London's very first financial document.

*Stations: Bank, Cannon Street, Mansion House          www.londonmithraeum.com*

## 50. Portsoken Pavilion, Aldgate Square and St Botolph Without Aldgate, EC3

This final entry of the book showcases the Portsoken Pavilion that sits in the very heart of the award-winning newly created Aldgate Square. It is a wonderful example of the City's knack of placing modern structures right beside the old – for Aldgate Square sits right between the Grade I listed St Botolph-Without-Aldgate Church and Grade II* Aldgate School, dating from the eighteenth and early twentieth centuries. Interestingly, it is also where Aldgate, one of the main entrances to the City of London, stood from the time the Romans erected their defensive wall around the City 2,000 years ago, until it was demolished in 1761. The gateway is furthermore where the poet Geoffrey Chaucer lived in the fourteenth century when employed as a customs official.

Portsoken pavilion was designed by Make Architects and opened as a community space and café in 2018. It was designed to be a focal part of the square and to service the local neighbourhood and office workers. It is an asymmetric steel structure described as 'monocoque' (meaning the frame and body are built as a single integrated structure) that touches down at only three points with sliding glass walls set between them. In many respects it bears a great similarity to the City of London Information Centre, Make Architects' pavilion beside St Paul's Cathedral, which opened in 2008.

From outside, the pavilion appears to occupy just one floor, but this is deceptive as there is a large area for kitchens and back-of-house facilities below. The building was initially a great success and a popular venue until it was forced to close down during the Covid-19 pandemic. It will no doubt re-establish itself as more workers

*Above*: Portsoken
Pavilion, Aldgate Square.
(© A. McMurdo)

*Right*: Portsoken Pavilion
and St Botolph Without
Aldgate. (© A. McMurdo)

return to their City offices and once again act as a community hub for those living, working or visiting the area.

In complete contrast to the glazed pavilion the church of St Botolph-without-Aldgate, designed between 1741 and 1744 by the famous architect George Dance the Elder (1695–1768), is a handsome brick and stone building. The church interior contains many interesting features including a Renatus Harris organ and a fine wood carving of King David surrounded by musical instruments.

*Station: Aldgate*             *www.stbotolphs.org.uk*

# Glossary

**Art deco**   An architectural and decorative style of the 1920s and 1930s that used vibrant colours and patterns.

**Art nouveau**   A popular style between 1890 and 1910 that is often characterised by its curves and swirling decoration.

**Baroque**   A flamboyant and monumental architectural style in fashion around 1600 to 1750.

**Brutalism**   An architectural style of the mid- to late 1900s. It features rough or raw concrete, often in large forms.

**Edwardian**   Covers the styles mainly in use during the reign of Edward VII (r. 1901–10), such as Gothic Revival, neo-Georgian and baroque revival.

**Georgian**   The style of architecture between 1714 and 1830, during the reigns of George I, II, III and IV, when classical proportions were introduced into all types of buildings.

**Gothic**   Refers to the style of the Middle Ages, which is renowned for its pointed arches, rib vaulting and large windows. Covers the period from around 1180 to 1520 and is divided into Early English Gothic, Decorated and Perpendicular styles.

**High-tech**   This style emerged in the 1970s, when designers selected lightweight building materials. It is characterised by the external exposure of mechanical services.

**Italianate**   This style of architecture was most prevalent in the early to mid-1800s. It is used in secular buildings and based on palatial homes in Renaissance Italy.

**Modernism**       This art and architectural style of the twentieth century discarded adornment and used modern materials in a minimalist fashion. It is typified by the use of reinforced concrete, iron, steel, metal and glass.

**Palladian**       Properly formulated, elegant and classical architecture introduced into England from the early 1600s.

**Postmodernism**   A movement of the late 1900s that departed from functional, conventional architecture. It merged art and functionality – creating an 'anything goes' culture – and incorporated the unusual use of colour and materials, historical elements and decoration.

**Victorian**       During the long reign of Queen Victoria (r. 1837–1901), many historic styles were prevalent such as Gothic Revival, Renaissance and Queen Anne Revival. Other popular styles included Italianate, neoclassical and Arts and Crafts.

# Acknowledgements

The author would like to thank all the people and organisations that have facilitated the production of this book. In particular, to acknowledge the help and assistance given by staff at Vintners' Hall.

Once again, I have to give great thanks to my husband Alex McMurdo for producing the majority of the images contained within these pages and for his wonderful support and encouragement during the writing of this book. Both he and Jo McMurdo have spent time proofreading the text and provided very useful feedback as well as constructive criticism.

I would also like to take this opportunity to thank Amberley Publishing for commissioning the book, and to acknowledge the excellent support and hard work of Jenny Bennett, Nick Grant, Becky Cadenhead and all the team.

# About the Author

Lucy McMurdo is a modern history graduate and native Londoner who has lived in the capital all her life. In 2003, when she qualified as a London Blue Badge Tourist Guide she combined two of her major loves – history and London – and has been sharing her knowledge of the city with local and foreign visitors ever since. Always keen to explore and learn about London's secrets, she spends many hours 'walking the streets' looking out for hidden corners, unusual curiosities as well as architecturally significant buildings and ones that have a story to tell.

Lucy's tour-guiding career began over thirty years ago when she first guided overseas visitors around the UK. Since then, in addition to tour guiding she has been greatly involved in training and examining the next generation of tour guides. She has created, taught and run courses in London's University of Westminster and City University, and also developed guide-training programmes for the warders and site guides at Hampton Court Palace.

Most recently Lucy has been writing about the city she is so passionate about and is the author of seven London guidebooks: *Highgate and Hampstead in 50 Buildings*, *Islington and Clerkenwell in 50 Buildings*, *Chiswick in 50 Buildings*, *Bloomsbury in 50 Buildings*, *Explore London's Square Mile*, *Streets of London* and *London in 7 Days*.